W9-ADI-804

SCHWINN

The Best Present Ever

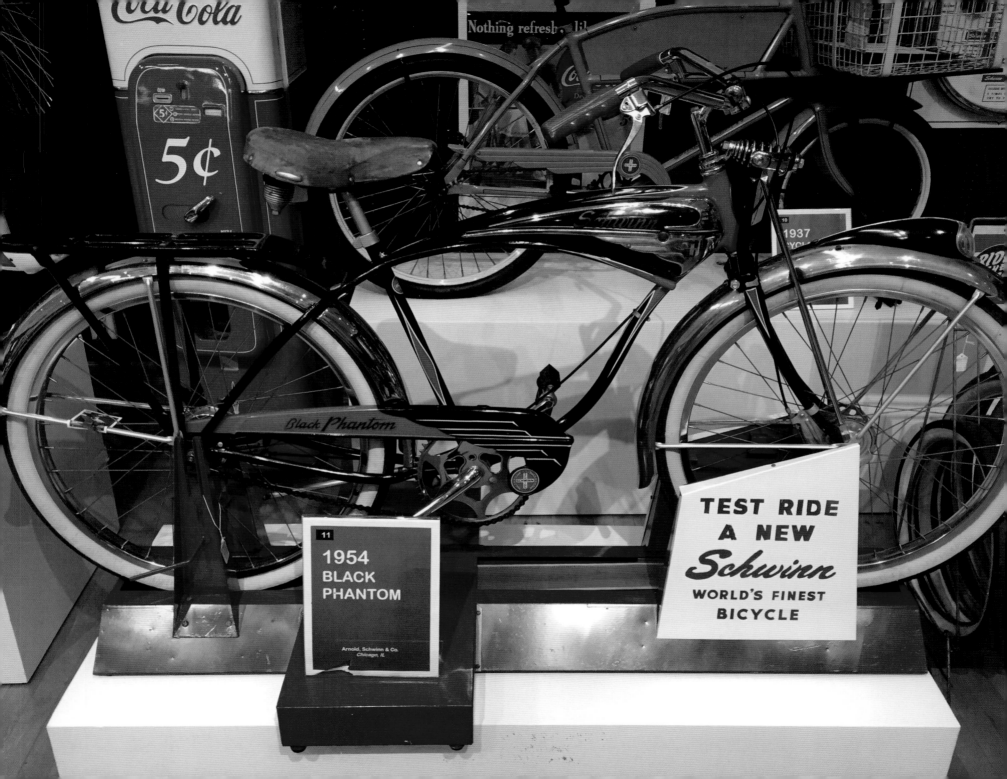

SCHWINN

The Best Present Ever

A CELEBRATION OF AMERICA'S FAVORITE BICYCLE

DON RAUF

PUBLISHED IN COOPERATION WITH PACIFIC CYCLE AND SCHWINN BIKES

LYONS PRESS

TITLE PAGE PHOTO: The Schwinn display at the Bicycle Museum of America. Author photo

An imprint of Globe Pequot

Distributed by NATIONAL BOOK NETWORK

British Library Cataloguing in Publication Information available

Library of Congress Cataloging-in-Publication Data available

ISBN 978-1-4930-3028-6 (hardcover)
ISBN 978-1-4930-3029-3 (e-book)

♾™ The paper used in this publication meets the minimum requirements of American National Standard for Information Sciences—Permanence of Paper for Printed Library Materials, ANSI/NISO Z39.48-1992.

Printed in the United States of America

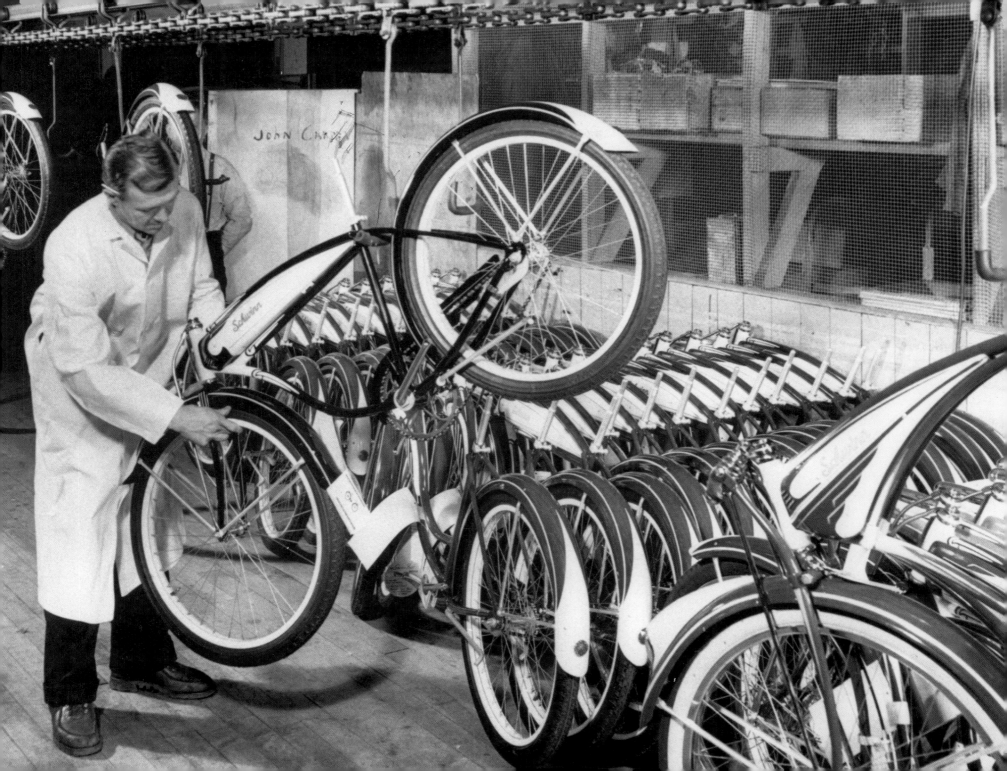

CONTENTS

INTRODUCTION

IN THE SUMMER OF 2016, the sci-fi Netflix series *Stranger Things* became a smash hit with its nostalgic look back at the early 1980s. Drawing inspiration from Steven King novels like *It* and *Firestarter* and Steven Spielberg films like *E.T.* and *Close Encounters of the Third Kind*, the story revolves around a group of kids who tear around town on their Schwinn-style Sting-Rays and BMX bicycles. The Sting-Ray, the low-riding "bike with the sports-car look," became an iconic bike from the 1960s to the early '80s With its distinctive banana seat, high-rise handlebars, and sissy bar in the back, the Sting-Ray was the cool bike every kid wanted to own. *Stranger Things* captures the romance of what the Schwinn Sting-Ray represented—a simpler time when kids could speed off on two wheels to explore and find adventure.

For so many kids growing up in America, a Schwinn was the ultimate gift. As one fan said: "One summer day my dad brought home a used Schwinn bike twice the size of me. Even though I couldn't sit on the seat and pedal it, I rode that bike proudly." In the decades to come, the Schwinn name would remain a highly regarded and sought-after brand.

Through the years, each generation has sped off on the popular model of the time to take trips, meet with friends, go to school, deliver papers, or simply get out in the world—and possibly away from parents for a break and a taste of independence. Many remember the fun of clipping baseball or playing

cards to the bicycle-frame fork with a clothespin so the cards would make a loud, motorcycle-like sound as they hit the spokes. For a century, since its beginnings in 1895, Chicago-based Schwinn represented the peak of American manufacturing and the bicycle industry. When customers bought a Schwinn, they knew they were getting a two-wheeled machine that was sturdy and built to last.

The Schwinn brand still carries a lot of prestige today for its style and long-lasting construction, and Pacific Cycle, which currently manufactures modern Schwinns, continues to reach back into the past, finding inspiration in the old styles and features that made the brand a favorite for generations of Americans. From the heavyweight balloon-tire bicycles to premium racing bikes and sporty Sting-Rays, Schwinn also established a reputation for innovation. Throughout its history, the company has always endeavored to be on the cutting edge, constantly on the lookout for the next big thing. Today it continues to incorporate modern technology, materials, and features in all of its bicycles, while still maintaining many of the design inspirations that have made Schwinn an iconic brand.

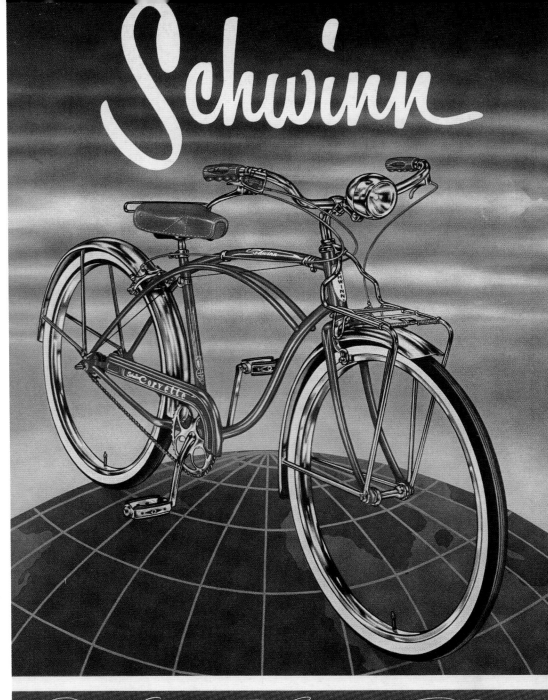

Chapter One

THE BIRTH OF THE MODERN BICYCLE

AROUND THE TIME Ignaz Schwinn arrived into the world on April 1, 1860, in Hardheim, Germany, the first real incarnation of the modern-day bicycle was also being born. In that decade, the Michaux family, coachbuilders from Paris, developed a two-wheeler with a wooden frame and two steel wheels. Riders propelled the contraption along using pedals and cranks. (Historians believe that a mechanic by the name of Pierre Lallement, who worked for the Michaux business, may have also played a role; he received a US patent for a two-wheeled vehicle with crank pedals in 1866.)

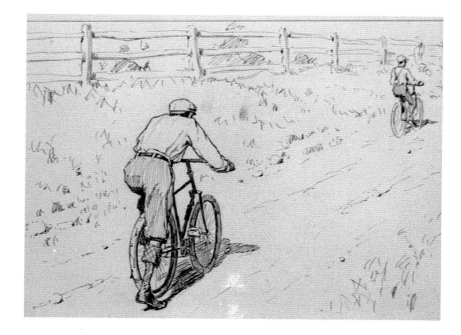

Courtesy of the Library of Congress.

This innovation in pedal power marked the real beginning of the modern bicycle. Prior to this, German Karl Drais had created a two-wheeled vehicle called the hobbyhorse (aka the running machine, and sometimes referred to as the "Draisine") in 1816. Riders sat in a saddle and steered with wooden handlebars, but to move the hobbyhorse forward they had to push their feet along the ground. The pedal-powered contraption from Michaux was dubbed the velocipede, but it quickly gained the nickname of "boneshaker," as riders were jarred by every bump in the road, primarily rattled by the rough cobblestone streets.

Draisine—
— 1816 —

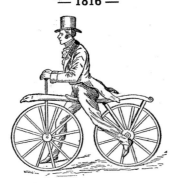

IN 1816 Baron von Drais devised a vehicle to assist him in his daily duties as Chief Forester of the Grand Duke of Baden, which was named the "draisine" after the inventor. As illustrated, the two tandem wheels of equal size were connected by a perch on which the rider partly sat, propelling it by thrusting his feet on the ground and guiding it by a bar connected with the front wheel and provided with a rest for the arms. In 1891 a handsome monument was erected to the memory of the "Father of the Bicycle" over his grave at Karlsruhe, the expenses of which were borne exclusively by bicyclists. This machine was very popular for a short time but as it was high-priced and not within reach of ordinary folk, it became known as the "dandy-horse" and "hobby-horse." About 1840, a Scotchman named Kirkpatrick McMillan, applied driving gears to a machine of the "draisine" type, and it is said he was prosecuted and fined for "furious driving" on the roads on his improved "dandy-horse."

LOBDELL Chromium-Plated RIMS and Streamlined Saddles are popular-priced and within the reach of all. In fact, quality, service and finish considered, they are the most moderately-priced equipment available.

Velocipede—
— 1865 —

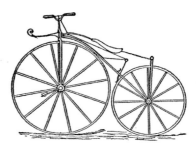

ABOUT the year 1865 M. Michaux and Pierre Lallement perfected a velocipede shown above with cranks and pedals fitted to the front wheel and surmounted by a wooden perch. It had heavy wooden wheels, thick iron tires and a massive iron backbone, extremely heavy, and vibrated in a terrifying manner over the rough roads, causing intense fatigue. This machine was dubbed "boneshaker" in England and became very popular in England and France, making cycling a fashionable pastime. Schools were established for teaching the art of riding and everybody who claimed to be anybody possessed a velocipede. So universal was the practice in fact, that at the Grand Opera House in Paris, straps were fastened to the walls for holding machines of fashionable velocipedists. This machine was patented in the United States in 1866, and the cycling mania spread like wildfire so that in 1869 manufacturers had all they could do to supply the demand.

The Chromium Plating on LOBDELL Rims remains permanently bright. To clean, just wipe off dirt or moisture and polish lightly with fine steel wool. No rust, no tarnish, no peeling or cracking. No bike complete without a LOBDELL Streamlined Saddle.

Ordinary or High
— 1873 —

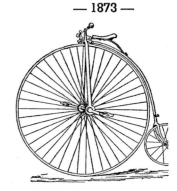

INVENTIVE ingenuity continued to make progress in England until 1873 when James Coventry produced the first machine embod of the features which were found in the ordina wheel. The driver was about three times as high wheel and both were provided with light metal wh tension, thin wire spokes and rubber tires cemen rims. In 1875 the average roadster weighed 65 p modifications and improvements of the ten yea which the bicycle enjoyed a halcyon career on bo the Atlantic, included design, color and adjustable ings, direct and tangent spokes and cushion tires. portant of these was the ball bearing introduce These were soon applied to all the moving parts of with the result that its propulsion was accompli far less effort and the rider was able to make f speed and to ride longer distances.

You never experience sudden, dangerou tiring road shocks when you ride a LOB Equipped Bike. They afford resiliency, and maximum safety for the rider. Good ing, too.

Following the boneshaker, the high wheel bicycle rolled into the world. Because its two wheels looked like a big English penny coin leading a smaller farthing coin, the public nicknamed this vehicle the "penny-farthing." Others called it the "ordinary." With an enormous front wheel, a cyclist could move farther with each rotation of the pedals compared to the old boneshaker. Although the high wheel bicycle might have traveled faster and provided more comfort with its rubber tires, cycling required daredevil-like skills. Riders had to hoist themselves high into the saddle and quickly gain their balance. Any small pothole could send cyclists toppling over from their high perch. Understandably, because of its precarious nature, the vehicle had limited appeal. The high wheel bicycle was deemed too risky—and perhaps risqué—for women, so manufacturers made a special tricycle directed toward females.

While the penny-farthing was one of the first two-wheelers to be called a bicycle, the next major innovation became the model for the bicycle as we know it today. In 1885, John Kemp Starley produced the Rover "safety bicycle." The invention featured two same-sized wheels, a frame similar to today's bikes, a steerable front wheel, and a chain drive linking the rear wheel to pedals attached to the frame with a sprocket. The concept was literally a turning point in bicycle history. With its two smaller wheels,

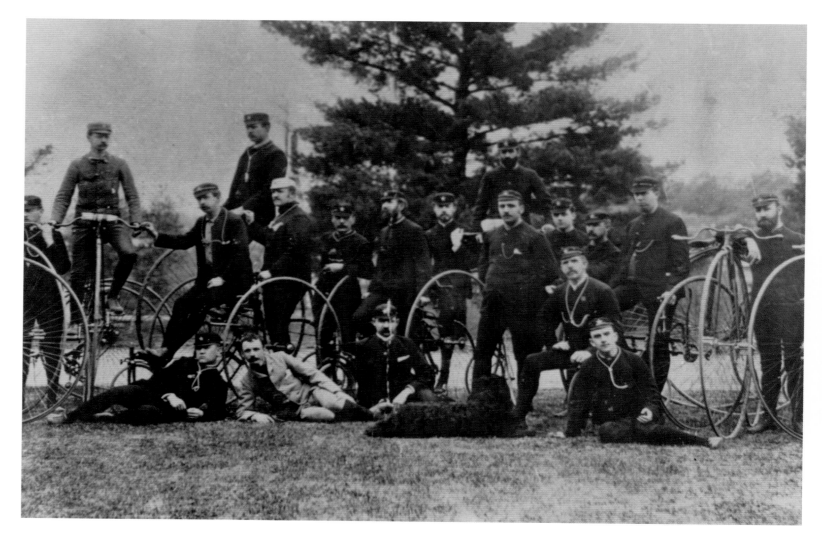

A talented craftsman and machinist, Ignaz Schwinn developed a keen interest in bicycle building at a young age. Because he was also a shrewd businessman, Schwinn established the dominant American bicycle brand of the twentieth century. Courtesy of the Bicycle Museum of America

this machine was much safer than the penny-farthing—hence the name. The safety bicycle design, with its diamond-style frame, would remain the foundation of bicycle construction for the next hundred-plus years.

Then, two years later, in 1887, John Dunlap struck upon another pivotal improvement when he developed a pneumatic, or air-filled, tire for his son's tricycle. Compressed air helped carry weight and absorb shocks. Using pneumatic tires on bicycles added a level of comfort that would boost the popularity of two-wheeled transportation even further.

With the introduction of these innovations, cycle-making took off in England at the end of the 1880s and quickly spread.

A PASSION FOR PEDAL POWER

As a mechanical engineer, Schwinn was captivated with the breakthrough of the safety bike. The trained machinist had learned extensively about metals and industrial tools while employed at various factories in Germany. In the mid-1880s as he labored at different bicycle shops, Schwinn dreamed of producing his own safety

bicycle for the public. He approached manufacturers with his designs, but many weren't yet sold on the basic safety bike concept; they wanted to stick with a proven thing: the high wheeler.

Schwinn, however, firmly believed in the cutting-edge idea. Eventually, he sold Heinrich Kleyer on his safety bicycle plan. Kleyer hired Schwinn to work in Frankfurt at his Kleyer Bicycle Works, where the company produced high wheelers under the brand name Adler (German for "eagle"). After Kleyer moved ahead, changing over from high wheelers to safeties in 1887, Schwinn became general manager of the plant at age twenty-nine. At the Kleyer factory, Schwinn made a diamond-frame bicycle that quickly became a hit, making the Kleyer Adler bicycles hugely popular in Germany.

Schwinn, however, grew restless. Realizing he couldn't rise above the position of factory manager at Kleyer, Schwinn set his sights on bigger and better things. He saw America as the land of opportunity. In the United States, the 1880s and '90s became known as the Age of Immigration, as waves of Europeans streamed into the country. Many were attracted by the unprecedented technological innovation and industrialization taking place there. While visiting relatives in Hamburg in 1891, Schwinn decided to buy a ticket aboard a ship bound for America. When he arrived, he found his manufacturing know-how in the bicycle business was in high demand, as the bicycle craze was just kicking into high gear.

THE BICYCLE BOOM OF THE GAY NINETIES

Because safety bikes with diamond frames and pneumatic tires made cycling easier and more enjoyable than ever, large numbers of people began taking to the streets on two-wheelers. Americans were embracing the bicycle as a fun and practical mode of transportation. According to the *Historical Dictionary of the Gilded Age*, edited by Leonard Schlup, the number of bicycles manufactured in the United States rose from more than 250,000 in 1894 to about 400,000 the following year. In Detroit, Michigan, about 80 percent of the city's population was shuttling about town on two-wheelers. At the bicycle-boom peak, manufacturers were cranking out about two million bicycles annually, according to David Herlihy, author of *Bicycle: The History*. Wheels were everywhere, as were wheelmen's clubs, which promoted the newfound pastime. As bicycling exploded in the mid-1890s, more than one hundred bicycle clubs were operating in Chicago alone.

With hundreds of companies churning out bicycles at a rapid clip, sales soared and prices dropped. To keep up with demand, however, the quality of many bikes also fell off; some manufacturers turned to inferior steel and poor-grade tires to slash prices further. In 1898, as the market became overstocked with two-wheelers, some retail prices dipped as low as $13.25 per bicycle.

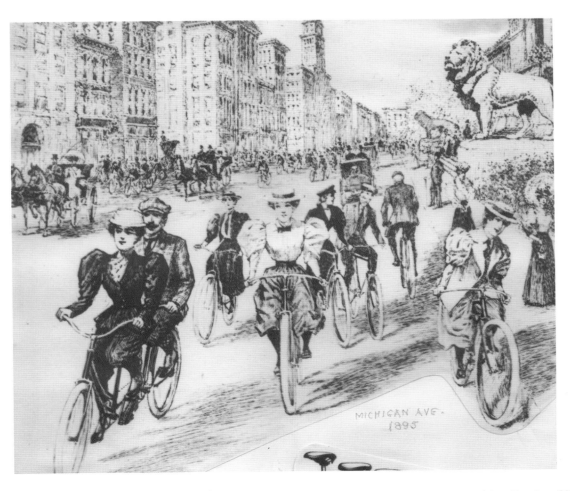

In the mid-1890s, men—and women—took to the streets on bicycles. For women, the bicycle became a means toward independence, getting them out of the house and into the world. Courtesy of the Bicycle Museum of America

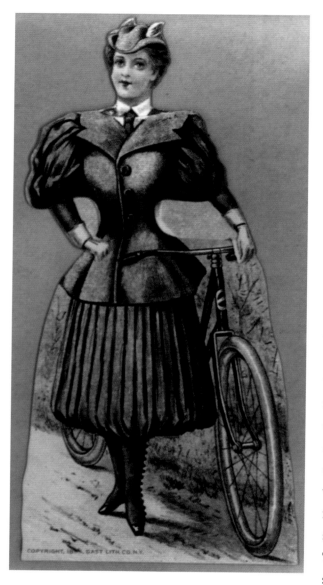

All in all, however, the access to bicycles by rich and poor alike was thought to have a positive social effect. People of all backgrounds rode together through the streets. Some believed that the two-wheeler would help erase class distinctions.

Historians say that the bike may have also aided the women's movement. Bicycles represented freedom. For the woman seeking more independence, it was a means to get out of the kitchen. The "new woman" worked outside of the home and became involved in the women's suffrage movement and other social causes. Because heavy skirts, bustles, and tight corsets greatly restricted mobility, women began cycling in bloomers, which some regarded as scandalous attire. Despite the fact that polite society considered bloomers fairly risqué, the wheelmen also promoted women wearing this style of garment, because it was simply "rational dress" for bicycle riding. The bloomer and the bicycle became symbols of women's rights. Susan B. Anthony wrote that the bicycle "has done more to emancipate women than anything else in the world. It gives women a feeling of freedom and self-reliance."

SCHWINN POISED FOR SUCCESS

Arriving in Chicago in 1891 with his wife Helen, the thirty-one-year-old bicycle enthusiast Schwinn was poised to take advantage of the growing wave in bike manufacturing just as it was beginning. Not only was Chicago the bicycle manufacturing capital of the world, but the city was also a center of technology and invention, chosen as the location for the next World's Fair, which would open in 1893. The Fair would present the world's most awe-inspiring innovations, such as the first Ferris wheel. Decorated in electric lights, the large spinning, glowing ride was a fitting symbol for this new thriving hub of the bicycle industry.

Schwinn and the improbable cyclist Baby Bliss. Courtesy of the Bicycle Museum of America

Ignaz Schwinn created a unique tandem that could accommodate him, his wife, and young son. Courtesy of the Bicycle Museum of America

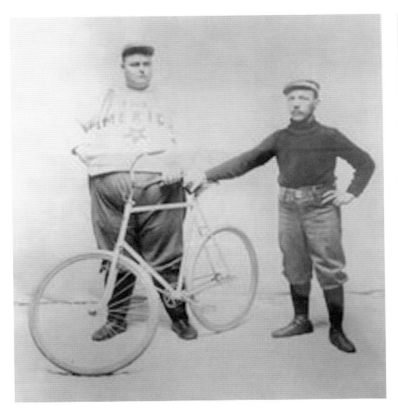

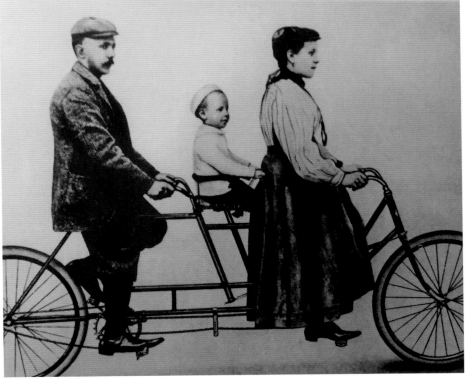

The German immigrant got straight to work, employed for a short time with Hill & Moffat, makers of the Fowler bicycle, and then moving on to design bicycles and set up a bicycle factory for the International Manufacturing Company.

During these years before forming his own company, Schwinn learned the value of publicity and promotion. He signed up cycling hero Baby Bliss to help publicize product. In today's world, Baby Bliss seems an unlikely cycling idol, nearly breaking the scales at 487 pounds!

In 1895, a fateful meeting set the course for Schwinn to produce bikes under his own name. That year, he made the acquaintance of Adolph Frederick William Arnold. Schwinn pitched the wealthy meatpacker the idea of opening a bicycling manufacturing operation under his leadership. Arnold agreed to fund the new business. The new partners incorporated Arnold, Schwinn and Company on October 22 of that year. Together, Arnold and Schwinn were determined to produce the highest-quality product possible and to develop the high end of the bicycle business.

Designed for both men and women, their first line of bikes, World Cycles, ranged in price from $100 to $125, and weighed just 19 to 24 pounds. The company touted the two-wheelers with an advertising pitch that may seem peculiar today: "We are always wide awake. Our line is alive." Arnold, Schwinn and Company used the best available steel tubing and brazed joints. Although lightweight bicycles like these would fade away a few generations later, the

By the end of the century, six-day races were all the rage.

style would come speeding back into fashion in decades to come. Ignaz showed off his passion for cycling, riding around Chicago with Helen on a special tandem called the "Combination," which also had a seat for their young child, Frank.

Beyond the regular consumer bike, Arnold, Schwinn and Company also focused on racing machines, and started a racing program. By the end of 1896, their racing team had more victories than any other bike manufacturer. The company constructed a five-rider pacing bike, and the single-speed World Racer and the Roadster, which were

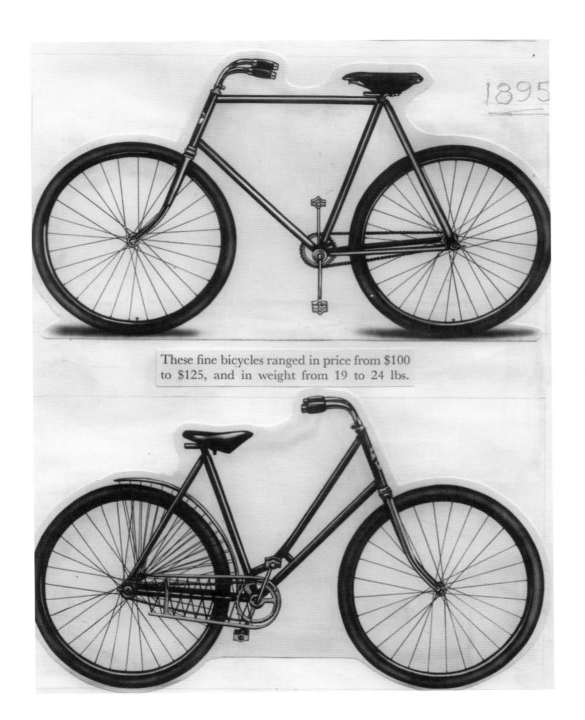

1895

These fine bicycles ranged in price from $100 to $125, and in weight from 19 to 24 lbs.

GEAR TALK

BRAZING: a metal-joining process in which two or more metal items are joined together by melting and flowing a filler metal into the joint.

both very light, at just about 19 pounds each. On June 30, 1899, Charles "Mile-a-Min-ute" Murphy rode a Schwinn when he became the first person in history to reach 60 mph, paced behind a locomotive.

By the end of the century, six-day races were all the rage. This was one of the most grueling, physically demanding sports of all time, as competitors would try to complete as many laps as possible around a wooden track. Some would ride for twenty-four

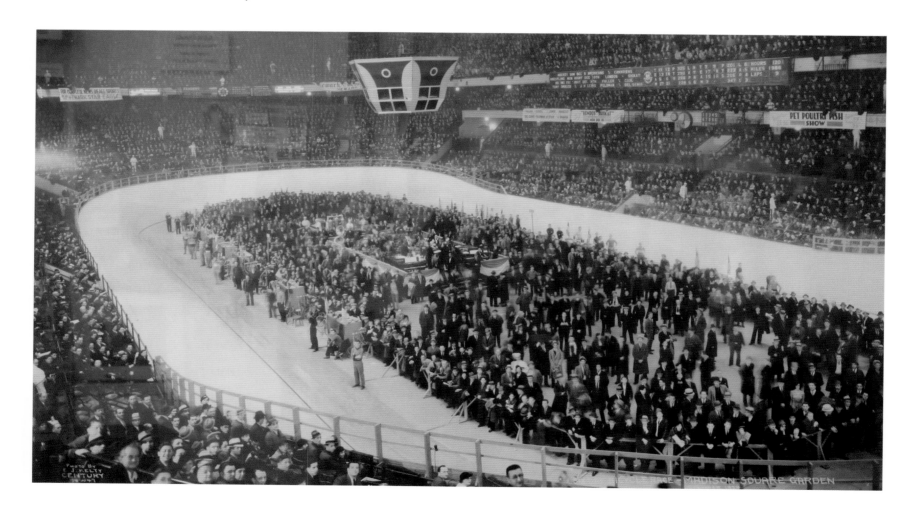

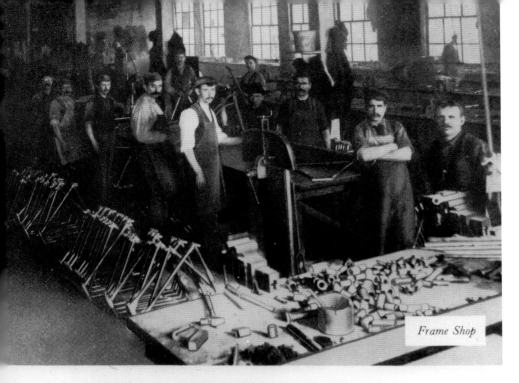

THE FACTORY · 1895

Frame Shop

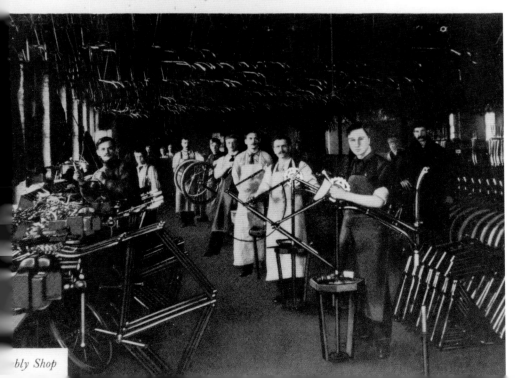

bly Shop

hours straight, limited only by their ability to stay awake. Top competitors were well paid, but the lack of sleep led to extreme exhaustion and even hallucinations that caused cyclists to fall.

SHIFTING INTO LOWER GEAR

As the century drew to a close, so did the public's passion for bicycles. The industry that was producing over one million units per year dropped by more than 75 percent. Many factors contributed to the sharp fall in business, including a glut of bike manufacturers and the rise of the automobile. Still, as the bicycle industry took a nosedive and many bike companies went out of business, Schwinn continued to pedal forward. The company succeeded with high-quality manufacturing and aggressive salesmanship, selling an average of about 26,000 units annually between 1895 and 1900, according to the *Standard Catalog of Schwinn Bicycles, 1895–2004*. Some models were not cheap. In 1902, a racing model cost about $150, or more than $3,500 in today's dollars. Arnold, Schwinn and Company sold the bicycles to retailers, including Sears, who added their names to the frames. The business owed a good deal of its success to developing a strong network of distributors and retailers, with one of its best markets in the heart of the cycling world, in Chicago.

MOTIVATED BY MOTORCYCLES

Schwinn had success in the 1910s and '20s manufacturing Excelsior and Henderson motorcycles. In 1912, an Excelsior was the first motorcycle officially timed at reaching 100 mph. Courtesy of the Bicycle Museum of America

In the mid- to late 1890s, Ignaz Schwinn was already thinking ahead, looking for the next big idea. With a budding interest in the latest technology of the internal combustion engine, Ignaz devoted his spare time to making a few experimental automobiles, as well as an electric car. One of his creations was a four-cylinder, water-cooled roadster built in 1905. It made sense that a cycle-maker would progress to automobile construction, since autos incorporated many of the same elements as bikes, such as chain and shaft drives, dependable tires, and differential gears. Schwinn's heart, however, still leaned toward two-wheeled transportation over four-wheeled.

By 1898, manufacturers were successfully combining the combustion engine with the structure of the bicycle to produce workable motorcycles. For Schwinn, motorcycle production seemed to be the logical path. His deep knowledge of bicycle manufacturing translated easily to motorcycles. The frames would simply be heavier versions of bicycle frames that he had been making all along. Plus, he had an in-house team of engineers who could take on the challenge, as well as an enthusiastic and eager son, Frank, who wanted to work alongside his father in the company business.

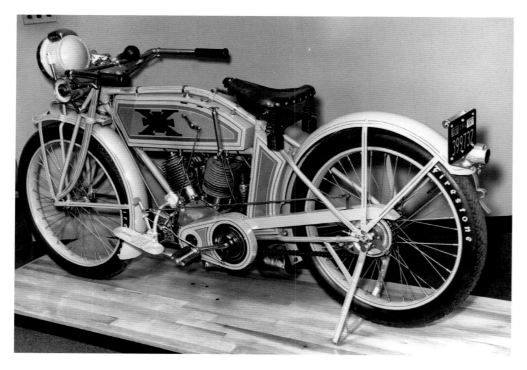

Before embarking on the new endeavor, Schwinn decided to part ways with his partner, Arnold. Although Arnold, Schwinn and Company had built and sold about 50,000 bikes in 1907, profits were incredibly slim. Breaking away from his original benefactor, in 1908, Schwinn became the sole owner of Arnold, Schwinn and Company. In 1909, he shifted his attention to the children's

market, developing tough bikes that could withstand the wear and tear from kids. He also dove into the motorcycle business with full energy.

In 1911, Schwinn purchased the bankrupt Excelsior Supply Company in Chicago for $500,000. This supplier of engine parts had begun making motorcycles, and Schwinn kept the Excelsior name for his new motorcycle division. When Schwinn bought their entire inventory, he was able to fulfill $200,000 in back orders. He made a shrewd move, as the motorcycle biz was about to take off. When Henderson Motorcycle Company of Detroit was struggling, Schwinn again saw an opportunity and purchased it in 1917.

In the 1910s, Americans and Europeans alike embraced the motorcycle. The US Army used them extensively in World War I (1914–18). As the motorcycle biz hummed along, Schwinn found a sizable market among police departments. Meanwhile, its sales of pedal-powered bicycles stagnated.

MOTORCYCLE STYLE CAPTIVATES KIDS

In the bicycle market, adults were steering away from pedal power to engine power, so Schwinn and other manufacturers shifted production toward making children's two-wheelers. The excitement of the adult motorcycle world, however, attracted kids as well. Schwinn spotted the growing enthusiasm among the little ones and applied the motorcycle mystique to children's products, bringing out a line of heavy frames and features such as a mock gas tank. In 1922, Schwinn's Motorbike (which was actually a bicycle and not a motorbike) and the Auto-Bike led the way into a new era of kids' heavyweight frames. These bikes continued to put on pounds as more extras came along, such as mudguards. Their simple fenders were considered a technological advancement in the biking world when introduced in 1925.

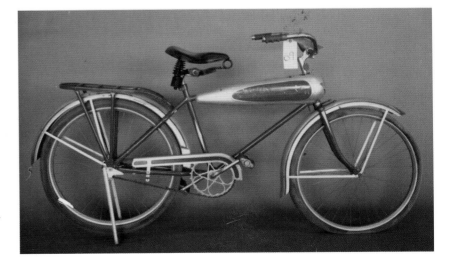

The Schwinn Motorbike introduced motorcycle-like features to kids' bicycles, such as a faux gas tank and fenders. Courtesy of the Bicycle Museum of America

Chapter Two

THE DEPRESSION YEARS: THE RISE OF THE BALLOON TIRE

WHEN THE GREAT DEPRESSION began in October of 1929, the motorcycle business almost skidded to a complete stop. With prices on automobiles steadily dropping as well, public interest in motorcycles waned. Ignaz also became disillusioned with motorcycles when a star on the Excelsior racing team died in a crash. All of these factors prompted Schwinn to gather his employees together one day in 1931 and tell them: "Gentlemen, today we stop." The Schwinn-produced line of Excelsior and Henderson motorcycles had come to an end; Ignaz retired; and his son, Frank, took the helm.

> For young adults in the Depression, a bicycle could be a cost-saving alternative to a car.

Throughout the ten years of the Great Depression, Schwinn, like many businesses, struggled to survive. But Frank Schwinn captained the company through choppy seas. Although several bicycle manufacturers churned out cheap products during these difficult times, Frank stayed the course, committed to quality even if the costs were higher.

For young adults in the Depression, a bicycle could be a cost-saving alternative to a car, but they still needed to be motivated to buy one. On a trip to Germany in 1933, Frank Schwinn came across an innovation that he thought would help revive bicycle sales.

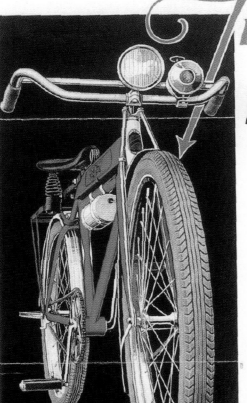

Arnold, Schwinn & Co.

Introduces Super Balloon Tire Bicycles

LOW PRESSURE
18 to 22 Lbs.
According to weight of rider

The only major development since the coaster brake—on the finest specially constructed bicycles built by the oldest and most outstanding American manufacturer. A 2⅛" automobile type double-tube, straight-side, cord tire—on a new deep drop center rim—a construction embodying all the latest advancements in the tire art.

ARNOLD, SCHWINN & CO.
1718 NORTH KILDARE AVE.
CHICAGO, ILLINOIS
TELEPHONE BELMONT 6793

MODEL B10E

The standard tire in America had been thin, like a garden hose, with no inner tube. While better than a solid rubber tire, these bike wheels still took quite a beating as they clattered over rough roads. In Germany, however, cyclists were cruising along cobblestone streets in relative comfort, cushioned by wider wheels called balloon tires. These were double-tubed, equipped with an outer rubber shell and an inner tube that could be easily repaired with a patch. Heavier bikes outfitted with these tires provided a more comfortable ride and lasted longer.

Arriving back in the United States, Schwinn was convinced that the balloon tire could be a success, especially on kids' bikes. The standard bike tire measured 28 inches in diameter by 1.5 inches wide, while the new balloon tire would have dimensions of 26 inches by 2.125 inches wide. They also required a lower air pressure, of 18 to 22 pounds per square inch. In general, a fat low-pressure tire like this softens a ride, conforming to bumps in the road, making rolling over rocks, branches, or other obstacles less jarring.

When Schwinn pitched the new balloon-tire concept to bicycle sellers in the United States, he was met with skepticism: "Why change the current system?" But Schwinn persisted, and when the company introduced the motorcycle-style B10E, the first US balloon-tire bicycle in 1933,

sales zoomed upward. Another motorcycle-style, balloon-tire model of the time, the Schwinn Cycleplane, kept the sales engine humming. An article in *Crain's Business* reported that shipments of heavyweight Schwinn kids' bikes ballooned 137 percent in two years, and the new-style tire became an industry standard. Even though Schwinns had a higher price tag than some other two-wheelers, people were willing to pay a little more for them because they knew that Schwinns lasted longer, making them a greater value in the long run.

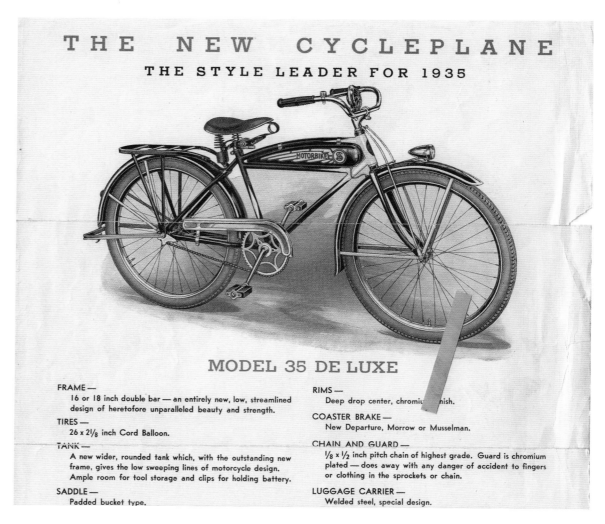

THE NEW CYCLEPLANE
THE STYLE LEADER FOR 1935

MODEL 35 DE LUXE

FRAME —
16 or 18 inch double bar — an entirely new, low, streamlined design of heretofore unparalleled beauty and strength.

TIRES —
26 x 2⅛ inch Cord Balloon.

TANK —
A new wider, rounded tank which, with the outstanding new frame, gives the low sweeping lines of motorcycle design. Ample room for tool storage and clips for holding battery.

SADDLE —
Padded bucket type.

RIMS —
Deep drop center, chromiu... nish.

COASTER BRAKE —
New Departure, Morrow or Musselman.

CHAIN AND GUARD —
⅛ x ½ inch pitch chain of highest grade. Guard is chromium plated — does away with any danger of accident to fingers or clothing in the sprockets or chain.

LUGGAGE CARRIER —
Welded steel, special design.

PLANES AND AUTOMOBILES DRIVE DESIGNS

The Streamline Aerocycle followed, taking its looks from the emerging aviation industry and designed to resemble an airplane fuselage. The red-and-silver Aerocycle, known as the "paperboy bike" or "cruiser," became widely popular. These "Super Balloon Tire Bicycles" often featured chrome fenders, a mock gas tank, and headlights. The balloon-tire bikes revolutionized the industry, and their streamlined looks and special features (headlights, reflectors, fenders, etc.) set a trend that would continue into the 1940s and '50s.

The revolutionary DC-3 airliner no doubt served as inspiration for the "streamlined" look that came to define industrial style, including Schwinn bicycles, in the 1930s. Courtesy of jgroup

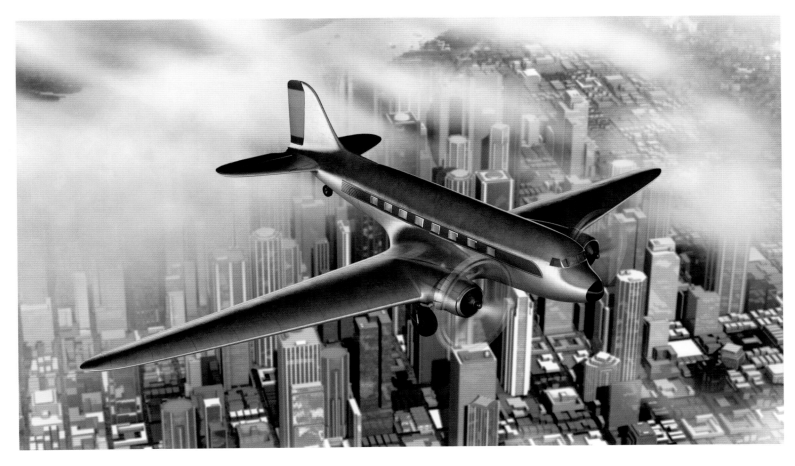

Rolled out in 1936, the Autocycle became another blockbuster. Drawing design inspiration from automobiles, the Autocycle also sported a speedometer mounted on a crossbar, a front fender reflector "bomb" ornament, and a seat supported by a coil spring, along with red rubber tires, pedals, and grips. The speedometer could light up at night. A battery contained in the tank, which was mounted to the frame, powered the headlight. Riders turned on the light or honked the horn by pushing Bakelite buttons on the tank. The Autocycle stayed in production until 1949.

In 1935, Schwinn presented the Cycelock (pronounced SIKE-lock) feature, followed by the Fore-Wheel Brake in 1938. Schwinn compared these new brakes to those on an automobile. Advertisements read "Squeeze gently on the handlebar lever to slow down. Squeeze harder and you stop instantly. Makes riding safer and easier." The 1938 model of the Autocycle brought more innovations: a cantilever frame, a chrome-feathered

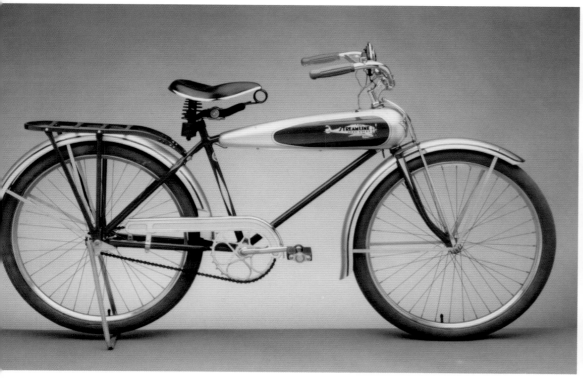

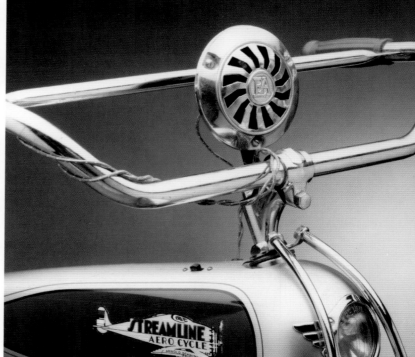

chain guard, and the spring front fork. Today, it's considered the grandfather of modern off-road bicycles. To add to its reputation for reliability and durability, Schwinn began offering a lifetime guarantee on all of its frames in 1939. That promise was smart marketing, and helped to increase sales by 100,000. Frank Schwinn had said that he would rather have 99 of 100 customers take advantage of him rather than have one customer not treated right.

That same year, the Cycle Truck delivery bike came along, and continued its run

GEAR TALK

CANTILEVER VS. DIAMOND FRAMES

A traditional style for bicycle construction for more than a hundred years, the diamond bicycle frame is a reliable and sturdy build for joining tubes. Compared to the diamond frame's more-angular shape, the cantilever has a graceful, swooping construction. The cantilever frame is popular on cruisers.

An ad from 1939 featuring the Autocycle. Since the country was still in the teeth of the Depression, lucky was the child who got his hands on one of these. Courtesy of the Bicycle Museum of America

RIGHT: The Cycle Truck was a favorite of delivery boys in the 1930s and '40s, able to haul up to 150 pounds in its front basket. Courtesy of the Bicycle Museum of America

"It's Schwinn-Built, Dad!"

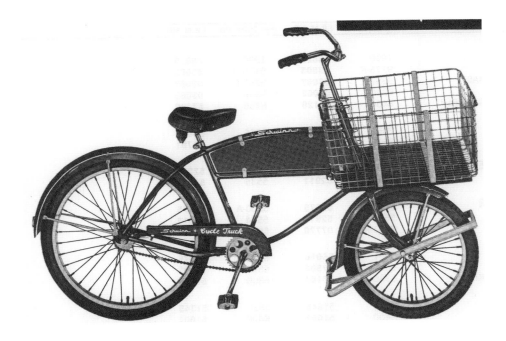

THE CYCELOCK FOR BUILT-IN SAFETY

Schwinn bikes had many exclusive features, including the Cycelock, which it provided on many of its models starting in 1935. Billed as "The Final Solution of the Bicycle Theft Problem," the Cycelock was a regular Yale lock constructed as part of the front fork. With a twist of a key on the Cycelock, a strong steel bolt would slide into a hole in the frame, keeping the front fork from turning and securing the front wheel solidly at a slight angle, so that the bicycle could not be ridden or rolled away. The bolt could not be reached from the outside or hammered apart. When unlocked, the key would stay fastened in the Cycelock, making it harder to lose the key. Because this built-in security system made it difficult for anyone to walk off with a precious Schwinn, it lowered the rate for theft insurance on these bikes. The Cycelock was abandoned as bikes became lighter; it not only added extra weight, but also wouldn't prevent a thief from running off with a lightweight model. (The Cycelock was more effective on heavyweight models, which were difficult and awkward to pick up to begin with.)

The Cycelock

THE SCHWINN CYCELOCK is an example of what we mean by "exclusive Schwinn features." They're not just added gadgets, but genuine improvements to protect you *and* your bicycle. And only Schwinn-Built bicycles have them.

The Cycelock is a regular Yale lock built right into the strong, drop-forged front fork, as in the upper picture. The lower picture shows how a strong steel bolt fits through a hole in the frame when the Cycelock is locked. The bolt cannot be reached from outside, nor can it be hammered back. This keeps the front fork from turning and locks the front wheel solidly at a slight angle, so that the bicycle cannot be ridden or rolled away.

The key remains in the Cycelock while it is unlocked and can't be missing when you want to lock up. Fewer lost keys that way, and no "borrowed" bicycle either, unless you say so. Whether you leave your wheel outside the store for just a few minutes, or all day in the rack at school, with a Cycelock you are sure you'll *ride* home!

Theft insurance carried by a large national insurance company takes a very low rate on bicycles equipped with the Cycelock. Your Schwinn dealer can tell you all about it.

LOOK FOR THE SCHWINN SEAL OF QUALITY ON THE FRAME—JUST UNDER THE SADDLE

Schwinn - BUILT BICYCLES

Page Four

Bicycle Museum of America

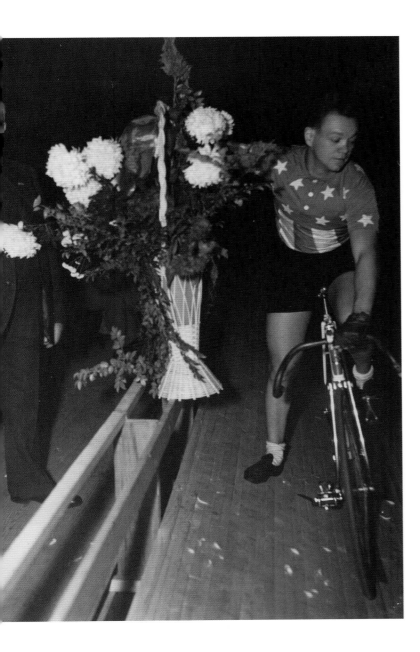

into the 1960s. This vehicle targeted boys who wanted to earn cash by delivering groceries, meats, drugstore items, or other goods. It could carry up to about 150 pounds. The frame was designed to hold a flat panel where a business could advertise itself.

THE LIGHTWEIGHTS STAY IN THE RACE

Although the balloon-tire heavyweights marketed to kids were generating big sales in the 1930s, Frank Schwinn maintained an interest in the lightweight models that had dominated as the 1800s came to an end. The six-day races that were so popular at that time had come back in fashion during the Roaring 1920s and '30s. In the big cities, crowds packed into arenas where the wooden racing tracks were set up. Packs of cyclists sped round and round, with victory usually going to the competitor who finished the most laps in six days. The possibility of a calamitous crash only added to the allure of the six-day race. Short curves on one oval track in Chicago earned it the nickname of "the suicide saucer." Al Capone and other gangsters often appeared and held court in the stands, betting on individual sprints.

Though retired, Ignaz Schwinn maintained a passion for racing throughout his later years. Here he is at a velodrome (a cycle-racing track with banked curves) in the 1930s. Courtesy of the Bicycle Museum of America

Frank Schwinn was not only inspired by the six-day races, but also by a growing appetite for speedy lightweights in Britain in the mid-1930s. Eager to revive the lightweight, Schwinn reached out to Emil Wastyn, a Chicago bicycle mechanic heavily involved in the six-day racing scene. He designed bikes for the Schwinn racing team.

In 1938, the company introduced the first Paramount high-end European-style racing bikes, designed by Wastyn. These hand-constructed diamond frames were sturdy but lightweight, made from high-strength steel-alloy tubing mated with lugs (socket-like sleeves) that were brass-brazed. All of the parts were the very best, either hand-crafted or imported from Europe. The cycles only weighed 18 to 20 pounds, about as much as a lightweight bike today. Highlights included a light and elegant crankset,

THE SCHWINN SPRINGER FORK

One of Schwinn's great innovations was coming up with a design that would help to absorb the shock when traveling over bumpy terrain. On many bikes, the front wheel is rigidly connected to the front fork. To provide a smooth ride, the company came up with a new patented approach, attaching the front fork independently using a tempered-steel coil spring so the rider would not be jolted when hitting rough spots or rugged roads.

drop handlebars, and a narrow sprinter saddle. Initially priced at $75 and marketed as road bikes for adult consumers, the bike was never able to turn a profit. The Paramount Sports-Tourist was a consumer model similar to the racing bike, meant for road touring.

For a lower-cost lightweight option, Schwinn came out with the Superior, which was similar to the Paramount, but with an imitation leather seat, less-expensive hubs, and other elements that cut the cost by about $25. In 1940, a very basic Schwinn lightweight called the New World arrived in stores, costing just $32. Frank Schwinn envisioned American adults incorporating the bicycle more into their daily lives to

The Paramount was Schwinn's premier high-end racing bike; it would remain a competitive cycle through the 1990s. Courtesy of the Bicycle Museum of America

RIGHT: A 1939 Schwinn Paramount built by Emil Wastyn's son Oscar. Courtesy of Classic Cycle

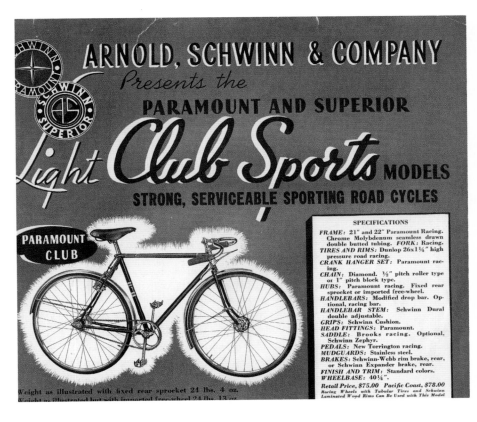

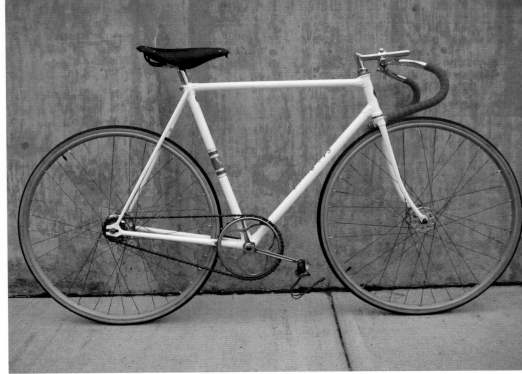

improve their health and for pleasure riding, errand running, and commuting. That year, however, the lightweights were not exactly sweeping the nation: Only about 5 percent of Schwinns sold in 1940 fell in the lightweight category, according to William Love's book, *Classic Schwinn Bicycles*. Several touring clubs, many affiliated with the League of American Wheelmen, popped up around the country, but a new lightweight cycling trend did not ignite on a larger scale at this time.

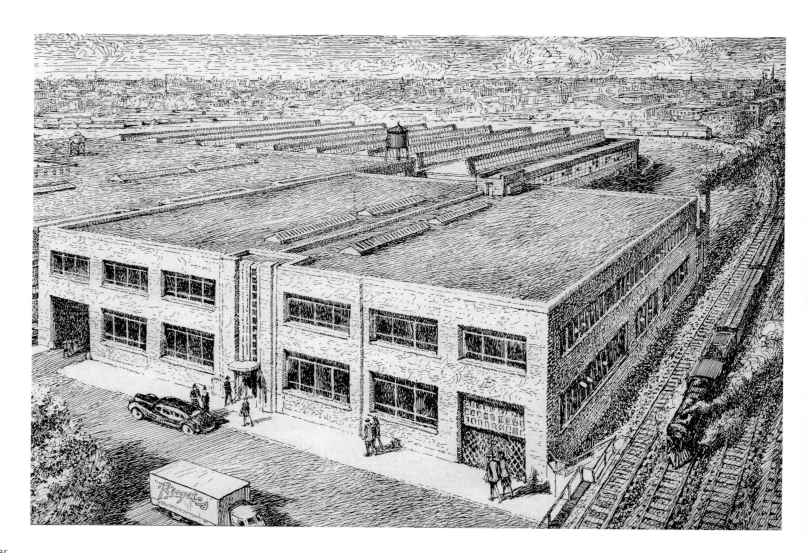

Praised among serious competitors, Paramounts were considered the finest of racing cycles. The line kept speeding along throughout the decades into the early 1970s. When Schwinn shut down the Paramount line in 1979, some models cost as much as $1,000. The Paramount line then went through a retooling. The operation was moved to Waterford, Wisconsin, where each Paramount bike would be custom-made to the exact specifications of its individual rider. The website for Waterford Precision Bikes says, "That year [1980], Schwinn brought back the Paramount as a super-custom bike—'anything you want' for the then-outrageous sum of $3,000. These became known as the 'Elite' Paramounts." Schwinn retired the line in 1994, but revived the name using different builders starting in 1998.

WORLD WAR II AND THE POSTWAR BOOM

IN THE 1940S AND '50S, Schwinn continued producing lightweights, but they didn't catch on at the time, as most adults were more interested in cruising the open roads in their cars. Bike sellers would have to wait until the latter half of the 1960s before American adults would once again truly embrace the lightweight (with the addition of ten-speed derailleurs) during a new bicycle boom.

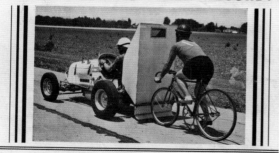

BREAKS WORLD SPEED RECORD!

ONE HUNDRED AND EIGHT MILES PER HOUR ON A SCHWINN-BUILT BIKE!...

—How's that for speed? Fastest mile ever pedalled, sanctioned and officially timed at 108.92 miles per hour by the American Automobile Association—ridden by Alfred LeTourneur on a Schwinn-Built Bike.

Two speed demons, Alfred LeTourneur, paced by Ronnie Householder in automobile, made this perilous ride against time on concrete highway. It required three miles to get up speed—four miles to stop after record was made. The front and rear wheels turned 22½ times per second, which carried the rider a distance of 159 feet per second. Several trials were run, electrically timed at 87.09—89.92—90.91 miles per hour. In practice, LeTourneur rode 12 miles with car speedometer reading between 97 and 100 miles per hour. The gear ratio used was 9½ to 1. This large sprocket, of course, would not be suitable for ordinary

riding. Long roller at bottom revolves to lessen danger if LeTourneur rides too close and wheel touches rear of shield.

It took expert riding to turn in a record like that—muscle, endurance and coordination! And a swell bike, too, to stand up under the gruelling punishment of such terrific speed, and still be in top condition!

LeTourneur's bicycle was a standard Schwinn-Built Racer (except for large sprocket). All Schwinn-Builts are built of such fine materials and with such expert workmanship that they're *Guaranteed for life!*

See the Schwinn line of Racers—many boys are buying them these days—light, fast and easy to pedal.

ARNOLD, SCHWINN & COMPANY
1718 North Kildare Avenue, Chicago, Illinois

SEE OTHER SIDE!

Form 168. Printed in U.S.A.

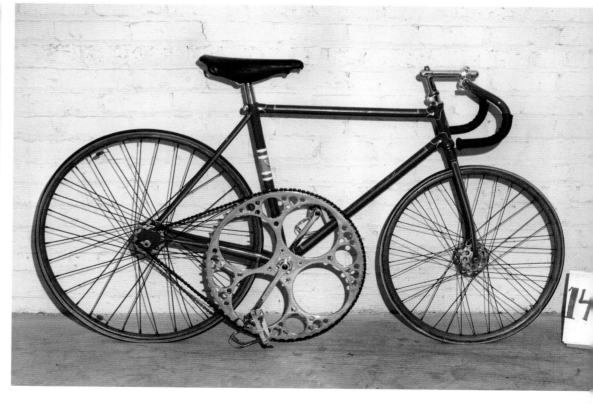

In the years leading up to World War II, however, Schwinn manufacturing rose dramatically, with 346,000 units produced in 1941, according to Lou Dzierzak in his book, *Schwinn*. In 1941, when America joined the battle against Nazi Germany and Japan, consumer bicycle production came to a standstill. The US government needed manufacturers to dedicate their energies to the war effort, and Schwinn, with its welding and metalworking machinery, was well positioned to do so. The Schwinn factory churned out about 10,000 basic, drab bike models annually for transportation around military bases. The company also had orders for the Cycle Truck, mostly used to deliver mail at military installations. In addition to bikes, the firm also cranked out airplane components, electrical devices, artillery shell casings, and ammunition. In 1943, Schwinn received the Army and Navy "E" award for Excellence for its superior manufacturing.

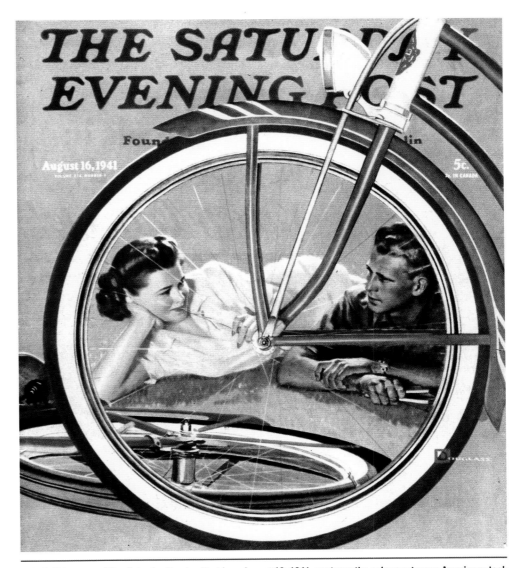

ABOVE: This cover of the *Saturday Evening Post* from August 16, 1941, captures the enjoyment many Americans took in riding bicycles just months before the attack on Pearl Harbor, when US involvement in World War II would change everything. Courtesy of the Bicycle Museum of America

OPPOSITE: On May 17, 1941, Alfred Letourneur was officially timed at 108.92 miles an hour, drafting behind race-car driver Ronney Householder. His bike was a standard Schwinn Paramount racer equipped with an enormous sprocket. The record gave Schwinn a huge boost of publicity for the Paramount. Courtesy of the Bicycle Museum of America

MODEL D37XE
Equipped

equipped with the fast selling Schwinn Spring Fork, Cyclock or Fore Wheel Brake, give the dealer exclusive models which are not competitive and produce greater profit. Only Schwinn-Built Bicycles have these exclusive features.

Specifications

MODEL: D36XE—16".
D37XE—18".
D38XE—20".
FRAME: Finest tubing available. Oxy-acetylene welded. Schwinn Patented Process.
FORK: Oval.
TIRES: 26x2⅛" Balloon—Bear.
HANDLEBAR: Boy Scout.
SADDLE: Mesinger, Ladies'.
PEDALS: Rubber padded.
GUARDS: 3" Crescent.
RIMS: Enameled to match.

COASTER BRAKE: New Departure, Morrow or Musselman.
TANK: New streamlined tank.
ELECTRIC HORN AND BATTERY CLIPS IN TANK.
ELECTRIC FENDERLITE, torpedo type, enameled.
REAR PARKING STAND.
CHAIN GUARD, enameled.
JEWEL REFLECTOR.
COLORS: Blue and cream, red and cream, black and cream; with cream guards, or guards to match frame.

Schwinn Spring Fork, Cyclock and Fore-Wheel Brake at small additional cost.

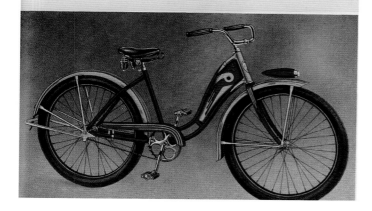

ABOVE: The Model D37XE from the 1941 catalog was rugged, good-looking, and moderately priced. Courtesy of the Bicycle Museum of America

RIGHT: Eager to help disabled soldiers, Frank Schwinn designed a bicycle supported by two side wheels, called the Quadracycle. The machine was intended to help veterans who might have difficulty riding a regular bike. Courtesy of the Bicycle Museum of America

To encourage disabled veterans to get exercise, Frank Schwinn created a Quadracyle, which was basically a bicycle with huge training wheels to help keep it steady. He sold a few, but as the war ended, he directed his attention back toward standard bike manufacturing.

The year after World War II ended, Schwinn pedaled full speed ahead, producing more than 300,000 bikes a year. The company also jumped into a new business, creating frames for the Whizzer motorbike. The frames resembled those on the balloon-tire classics, but a bit bigger. Although the single-cylinder Whizzer could only travel at a top speed of about 40 mph, the vehicle proved to be popular among the postwar

generation, who were eager to save a buck. The motorbike averaged about 125 miles per gallon of gas. They sold a couple hundred thousand in 1948.

In the 1940s, several Hollywood celebrities either endorsed Schwinn bikes or were featured with the cycles in films. This love affair between Hollywood and the classic American bicycle would continue over the next three decades.

Whizzer motorbikes buzzed onto the scene in the 1940s, giving postwar America an economical option for getting around town. Actress Dorothy Lamour was an "ambassador" for the Whizzer and other Schwinn products, and is seen here promoting her new 1947 film, *My Favorite Brunette*. Courtesy of the Bicycle Museum of America

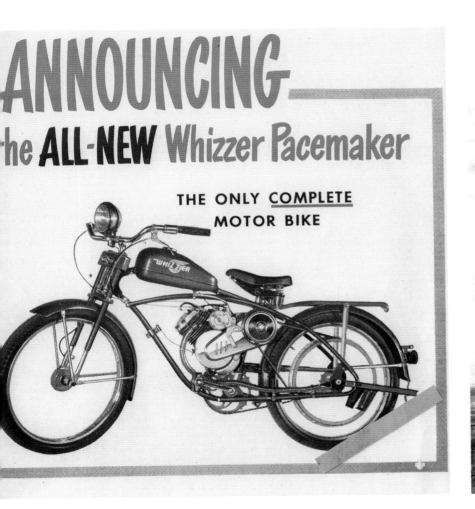

ANNOUNCING the ALL-NEW Whizzer Pacemaker

THE ONLY COMPLETE MOTOR BIKE

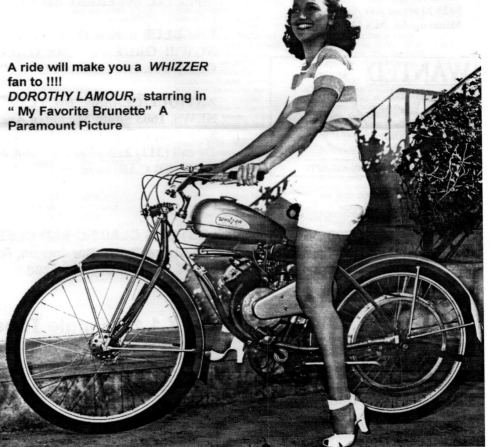

A ride will make you a *WHIZZER* fan to !!!!
DOROTHY LAMOUR, starring in " My Favorite Brunette" A Paramount Picture

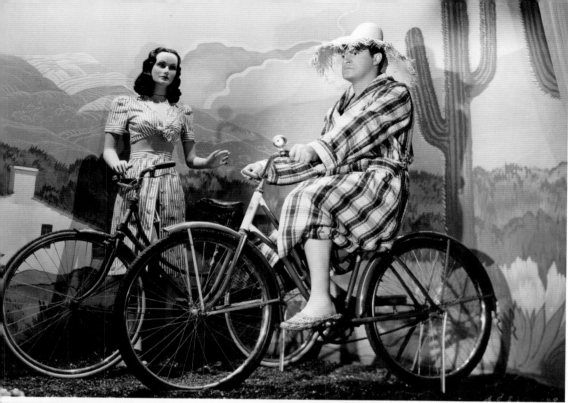

LEFT TOP: In the 1943 screwball caper *They Got Me Covered*, Bob Hope tries to elude spies by posing as a mannequin sitting on a Schwinn (which goes well until he accidentally rings the bike bell). RKO Radio Pictures via Steven Rea's *Hollywood Rides a Bike* collection

LEFT BOTTOM and BELOW: Bing Crosby and his four boys also promoted Schwinns: "We Crosbys have been riding Schwinn-built bicycles for years now. . . . Cycling on a Schwinn is clean fun and healthful sport for man or boy." Courtesy of the Bicycle Museum of America

Schwinn-Built Bicycles

knowledge, of skilled craftsmanship, of technological progress—to making bicycles that are just as fine in their way as the new automobiles and clipper planes. New steels, new processes, new machines, new tests, new ideas, new safety and luxury and comfort . . . *all* go into the making of these superb bicycles that we proudly mark as Schwinn-Built. In one of the most modern factories in America, we are building for you the bicycles that *set the pace* for the cycle industry. We invite you to read about these bicycles . . . and to imagine yourself spinning off on one of them. Boy or man, girl or woman—there's no age limit to a thrill like this. It's great to ride . . . when you ride a Schwinn-Built bicycle—the only bicycle guaranteed for life!

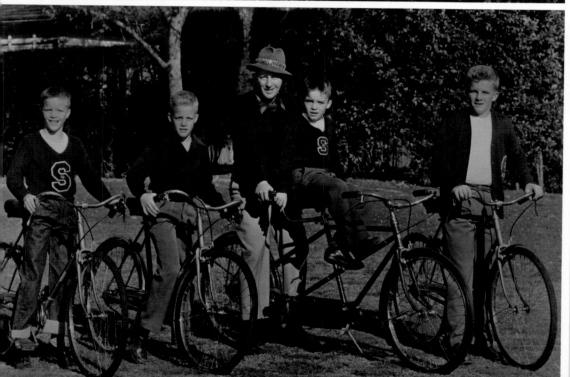

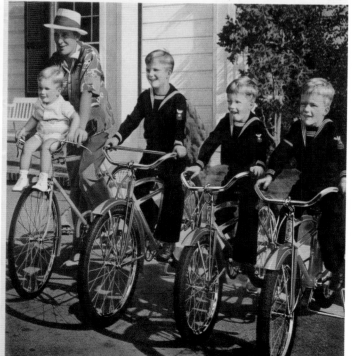

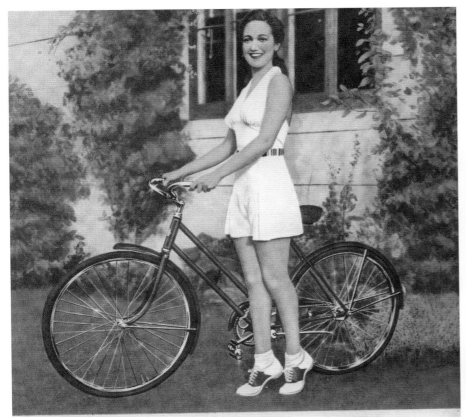

DOROTHY LAMOUR . . . "triple-glamour" (voice, face, figure), Paramount player and star of "Road to Zanzibar" soon to be released, admires the glamour lines of her Schwinn-Built mount.

For Health and Pleasure!
Schwinn-Built Bicycles

LEFT: Naturally glamorous Dorothy Lamour, who played the love interest in many of the Hope and Crosby "Road" movies, got in on the Schwinn action. Here she is pictured in saddle shoes, ankle socks, and shorts next to a lightweight Schwinn. Courtesy of the Bicycle Museum of America

LEFT: Naturally glamorous Dorothy Lamour, who played the love interest in many of the Hope and Crosby "Road" movies, got in on the Schwinn action. Here she is pictured in saddle shoes, ankle socks, and shorts next to a lightweight Schwinn. Courtesy of the Bicycle Museum of America

BELOW: Joan Crawford helps Clark Gable holster his pistol on a Hollywood backlot while riding a Schwinn. MGM via Steven Rea's *Hollywood Rides a Bike* collection

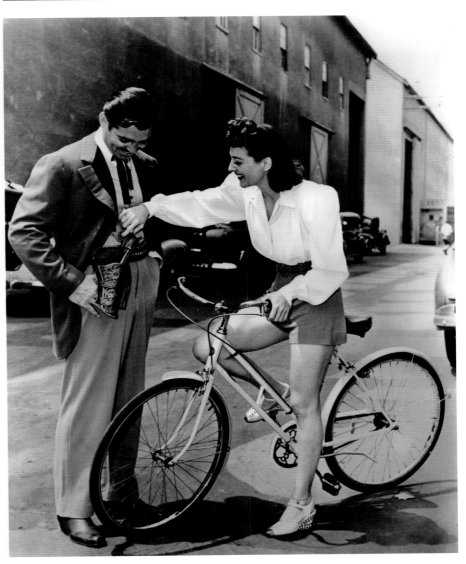

THE FIFTIES: THE NEW HEAVYWEIGHT CHAMPIONS

THE 1950S WERE A TIME OF THRIVING pop culture in America—it was the era of rock 'n' roll, Elvis, soda fountains, hula hoops, and *Leave It to Beaver*. For many, it was a time of excitement, when America was at its peak. For Schwinn, its heavyweight balloon-tire bikes fit into the cultural tapestry. Echoing the powerful and bulky automobiles of the era, like Buicks, Cadillacs, and Chevys, the Schwinn bikes struck a chord with American youth, who found them irresistible.

THE BLACK PHANTOM: AMERICA'S MOST DESIRABLE BIKE

After the end of World War II, America experienced both an economic and a baby boom. (About four million babies were born each year during the 1950s.) Schwinn was poised to take advantage of both when it introduced one of its most iconic bicycles, the Black Phantom. With the worries and weight of the war lifted, Americans were looking for some excitement—and that's just what the Phantom delivered.

While the Phantom came in red and green as well, it was the black model that turned out to be the most iconic and sought after. Every boy in America dreamed of getting a Black Phantom for Christmas or a birthday. Some kids would save up their allowance money or earnings from an afterschool job to buy one. And reaching that goal took some time and effort; these two-wheelers weren't cheap. While other bikes cost as little as $17, the price tag for the Phantom was about $60 to $75, or the equivalent of about $590 to $740 today. Schwinn, however, was known for making bicycles of the highest quality that were meant to last, so the price was well worth it. Plus, the Black Phantom was considered "the Cadillac of bicycles." Not only was it stylish and a smooth ride, it was also a real status symbol. The Black Phantom became a runaway success, and it helped Schwinn to secure about one-quarter of the bicycle market in the early 1950s.

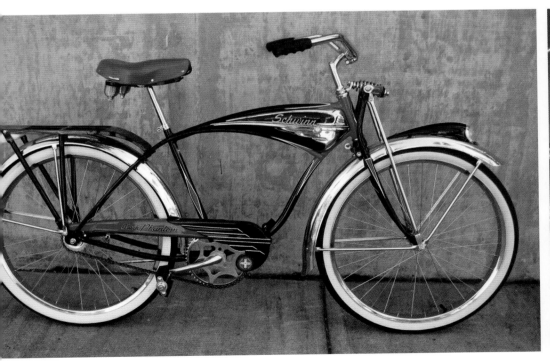

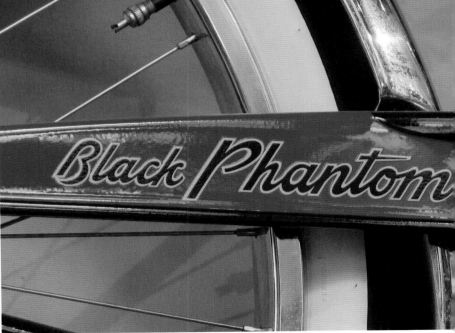

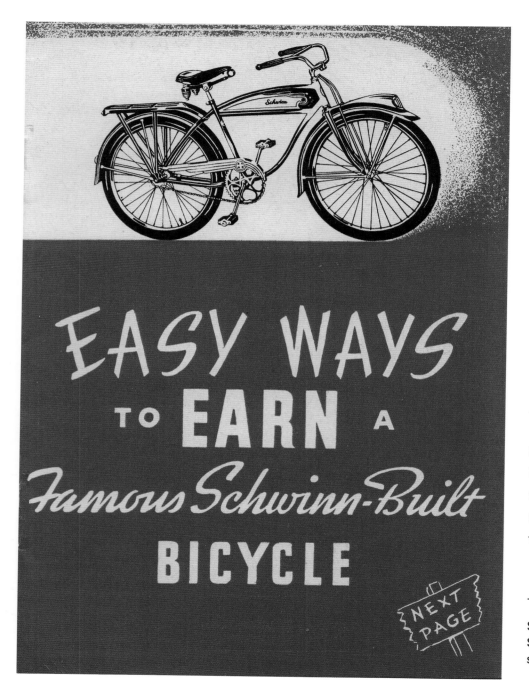

EASY WAYS TO EARN A Famous Schwinn-Built BICYCLE

NEXT PAGE

Sue Perkins wrote in her novel, titled *Schwinn Black Phantom*: "All my pals were wishing for that same bike....I had earned half the money by delivering papers; Dad paid the other half."

As far as engineering was concerned, this two-wheeler did not break any new ground; it was a basic cruiser that in many ways was similar to previous Schwinn models like the Autocycle. When it was introduced in 1949, however, the Phantom line captivated consumers with its luxurious style and accessories. As one advertisement said: "[It's] completely equipped with every accessory imaginable to delight the eye of every youngster. Finest Schwinn craftsmanship throughout. The proudest achievement of three generations of experience in designing and building fine bicycles makes the Phantom the most wonderful bike any boy can own!"

Schwinn touted the cantilever frame, built-in kickstand, handsome rear reflector, a rear carrier rack, integrated headlight, the battery-powered swooping horn tank, deluxe leather saddle, and wide whitewall tires. And although it was almost

Schwinn even advised kids on how they could earn money to buy a pricey Schwinn such as the Black Phantom through pamphlets like this one. Courtesy of the Bicycle Museum of America

all black, the Black Phantom boasted red highlights and shiny chrome fenders. With its patented springer fork connecting to the front wheel, the Phantoms were in some ways like today's mountain bikes, in that they could ride over rough ground, making for a smoother ride compared to other bikes. It also featured the unique built-in Cycelock for security. With all its "bells and whistles" and sturdy construction, it's no surprise that the Phantom weighed in at about 55 to 67 pounds, depending on what features came attached.

"These bikes were so coveted and awe-inspiring that no kid would even consider riding the Black Phantom on his newspaper route. The bike was the prize that two years of saved route money bought in the first place! The Phantom was the ride for sunny days and impressing the other guys in the neighborhood. This wouldn't end up a 'work' bike; that job would still belong to the rusty old Roadmaster in the garage."

—CLASSIC CYCLE, SEATTLE, WASHINGTON

Black Phantom "Fenderlite" detail. Photo by Scott M. X. Turner, taken at Classic Cycle

GEAR TALK

CRUISER: A category of bicycles that was designed for casual riding as opposed to racing or going long distances. Known for their comfort, typical cruisers have upright handlebars and are ridden in an upright position (unlike road bikes, which require an extreme forward-leaning stance). Most are distinguished by balloon tires, a single-speed drivetrain, and a steel body.

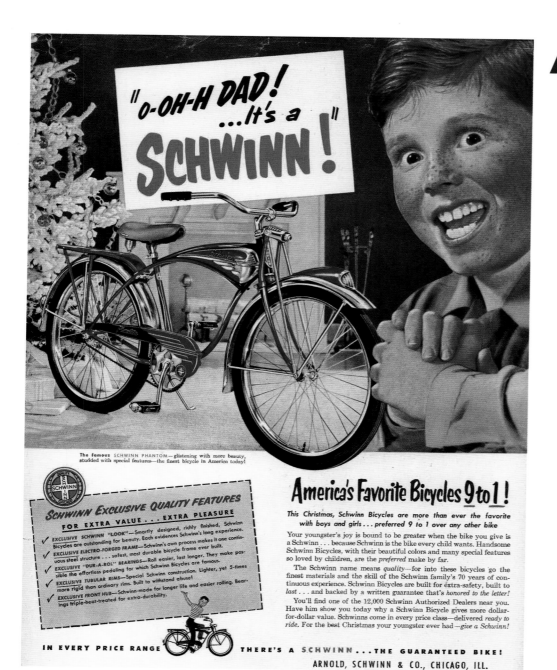

A HUGE SALES PUSH

When done right, advertising can have a major impact on sales. Schwinn lifted its sales in 1952 with one of its biggest campaigns, placing print ads in 114 newspapers and magazines, such as *Life*, *Look*, and *Collier's*. The slogan in all the ads read: "Schwinn—The Perfect Gift for Christmas." The push helped Schwinn gain a significant share of the bike market. Note, too, that Schwinn introduced a selective retail distribution and franchise program in 1952, which also helped to move their product. Before this time, the bicycles were sold through a wide range of outlets, including hardware stores and gas stations. Schwinn then shifted its strategy, selling through dealers who cared about the product and focused on promoting the Schwinn brand.

The Black Phantom was originally introduced in a 26-inch model that would be suitable for young adults on up, but, realizing the popularity of this version, Schwinn began offering a 24-inch juvenile model in 1950 so younger kids could also join in the fun. The smaller version sported a powerful Delta Rocket Ray headlight instead of the standard Fenderlite. The younger kids' Phantom was discontinued after 1954, but Schwinn produced a girl's Phantom in 1955, which came in black as well as a two-tone-blue

Schwinn's ads for the Phantom often depicted kids in a fever-pitch rapture over the bike.
Courtesy of the Bicycle Museum of America

"As a kid in the early '50s, I dreamed of having the 'Cadillac' of bicycles, a Schwinn Black Phantom, with whitewall tires and a streamline fender light. Phantoms were sleek and traveled fast."

—WAYNE NALLS IN *MENTOR IN THE MIRROR*

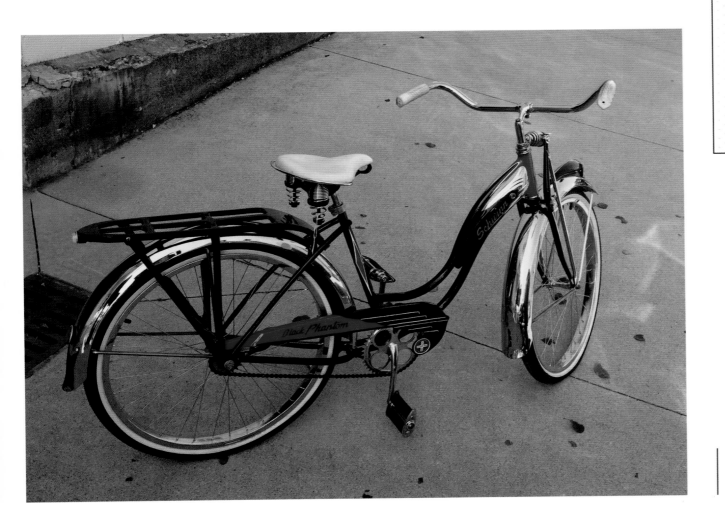

A rare example of the girl's version of the Black Phantom. Courtesy of the Bicycle Museum of America

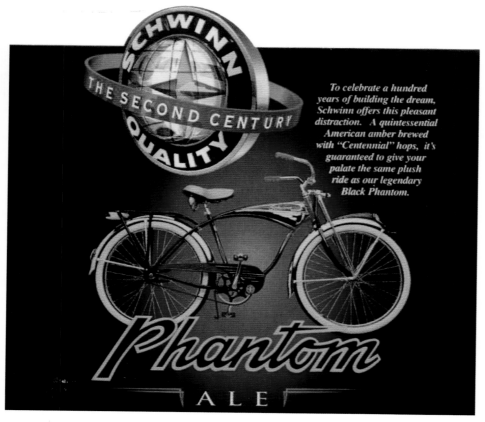

To celebrate a hundred years of building the dream, Schwinn offers this pleasant distraction. A quintessential American amber brewed with "Centennial" hops, it's guaranteed to give your palate the same plush ride as our legendary Black Phantom.

color combination. Because this model was primarily geared toward boys, the experimental girl's model lasted only a year—which makes finding one today an exceedingly rare event.

Ten years after the Black Phantom took America by storm, the trend was over. As the biking public looked for lighter-weight rides, the heavyweight cruisers started to fade out. All the accessories, like racks and tank horns, were extra baggage, weighing down cyclists who were looking to move at a faster pace. By 1960, America's youth were embracing the "English Racers" with their thin tires and different gears. These bikes were easier to maneuver and built for speed. Realizing the consumer change, Schwinn shifted gears and began producing middleweights—two-wheelers with the same craft and durability, but lighter.

For many bicycle enthusiasts today, the Black Phantom captures a nostalgia for the 1950s; they are among the most desirable and collectible two-wheelers. A well-restored original can fetch as much as $2,000 on eBay. To celebrate the one hundredth anniversary of the Schwinn company in 1995, the Scott Sports Group (Schwinn's owner at

For those on a small budget with limited space, Xonex issued a tiny scale model of the Black Phantom in 1990, capturing the smallest details, including a screen-printed chain guard. The famous bike also appeared on the label of a limited-run beer celebrating one hundred years of Schwinn. Courtesy of the Bicycle Museum of America

the time) produced a limited-run replica of the Black Phantom that retailed for $3,000. Fans and private collectors quickly scooped up the few thousand reproductions. Many have kept them in their original boxes as an investment, untouched in garages around the country. To celebrate Schwinn's centennial, a beer called Phantom Ale was also crafted. The label promised that the beer was "guaranteed to give your palate the same plush ride as our legendary Black Phantom."

THE BIG CATS: PANTHER AND JAGUAR

For those who couldn't afford the Phantom, Schwinn offered a similar bike that wasn't quite as deluxe but cost a few dollars less, called the Panther. This model still boasted plenty of frills—decked out in chrome (including the seat springs), with extra-deep

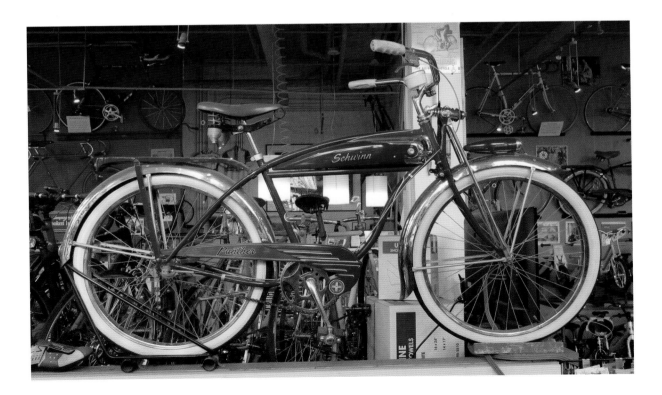

fenders, springer forks, whitewall tires, a powerful Rocket Ray headlight, and a rear rack. The frame, however, paralleled the Motorbike style, and the horn tank looked blockier, lacking the swoop of the Phantom's tank.

The Panthers came in two-tone blue, two-tone green, red, and a two-tone red that resembled Pee-wee Herman's famous bike. This heavyweight version of the Panther lasted from 1950 to 1954. In 1959, the model was reborn in a middleweight version. The Panther II leapt out as a trimmer, sleeker, and faster upgrade. Although it lasted only through 1960, the new incarnation of the Panther now had a slick cantilever frame, along with a small, trim-line horn tank (known as a half tank), front and rear carriers,

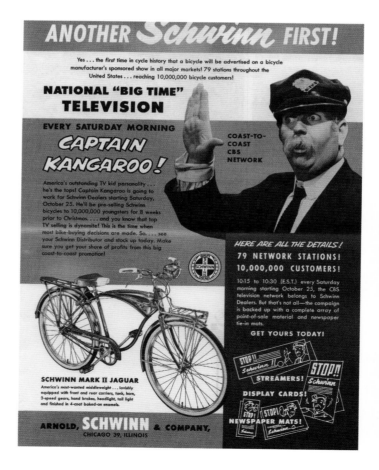

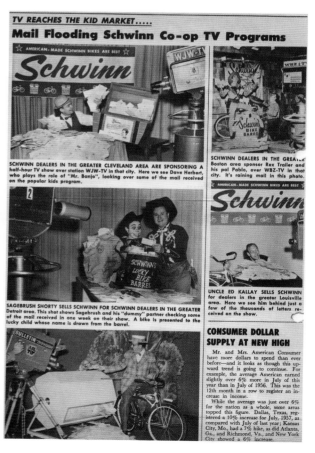

stainless-steel fenders, and a Schwinn monogram reflector and saddle. The chain guard was larger and sturdier. Plus, the Panther now offered options in terms of speed: Consumers could buy a three-speed with caliper brakes, a two-speed with coaster brakes, or a regular one-speed with coaster brakes.

The Panther received a final makeover in 1961. The Panther III had some slight style adjustments, but it was virtually the same as the Panther II. Schwinn ended the Panther line a year later. In today's bike-collecting market, the twin headlights are especially sought after; the headlights alone can sell for as much as $300.

Schwinn capitalized on popular car models at the time, and dubbed a 1954 addition to their heavyweight category the Jaguar. The line never had a girl's version, and only appeared in 26-inch frames. The Jaguar came with a three-speed hub option and hand brakes. After selling as a heavyweight through 1955, the Jaguar took a hiatus for a year, and reappeared as a middleweight in 1957 with a Phantom-style horn tank and taillight. Different updates of the Jaguar appeared along the way, including the Jaguar Mark V (1963–64), which touted the special feature of a spring-type front fork. To have some idea of the Mark V price, the 1964 catalog listed the single-speed coaster at $76.95, and the automatic two-speed at $86.95.

The automatic two-speed had an interesting shifting mechanism called the Bendix hub. (Note that the Bendix was also often referred to as the "triple-band hub," because it had either three yellow or red stripes painted on the outside.) To change gears, you made a slight kickback motion; backpedal harder, and the coaster brake brought things to a stop. You had to learn to backpedal just right to activate either the brake or the gear change. The Jaguar was discontinued in 1965 with the Mark VI.

HEAVY INSECTS: THE HORNET AND THE WASP

Around the same time the Phantom stormed the market, the Hornet came buzzing along in 1949 as an even more affordable option for both boys and girls. Like the Phantom, the Hornet tipped the scales as a heavyweight with balloon tires, a horn tank, a sturdy rack, and fender-mounted headlight, but because it had a simpler design without as many bells and whistles, the Hornet was easier on the pocketbook. The Hornet

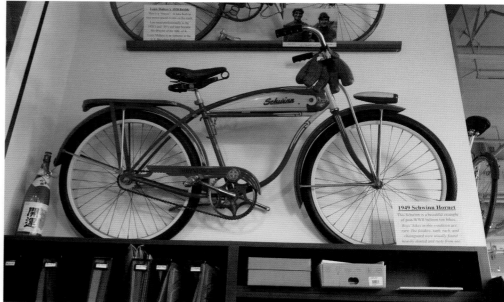

lacked a major highlight that gave both the Phantom and the Panther a certain "wow" factor: It had no chrome. It also didn't come with the comfort of the springer fork (unless you paid for the deluxe version). The bike did display a spiffy hornet character on the chain guard. In 1956, the Hornet morphed into a middleweight and went through various transformations until the line was discontinued in 1964. In 1960, the bike was selling for between $52 and $60.

Another lower-priced heavyweight balloon model was the Wasp, with its cantilever frame. The Wasp flew in during 1954 and made its last appearance in 1964, staying a heavyweight throughout its run. Other bikes in the heavyweight category were the Spitfire, the Meteor, the Leader, and the Streamliner.

In the 1950s Schwinn bicycles continued to be a feature of Hollywood's backlots. Here a young Natalie Wood bestrides a classic ladies step-through. William R. Woodfield / Globe Photos, via Steven Rea's *Hollywood Rides a Bike* collection

Chapter Five

THE MIDDLEWEIGHT CONTENDERS

WANTING TO CAPITALIZE ON a changing consumer appetite for a lighter bicycle, Schwinn ushered in a line of middleweights. These bicycles offered slimmer frames with thinner tires. As Schwinn boasted at the time, the new tires combined balloon-type dependability with lightweight features. Called S-7s, the new tires dropped in width from 2.125 inches to 1.75 inches. The old balloon tires had a low pressure of 18 to 22 pounds per square inch (psi), compared to these thin, tubular-design wheels, which held 44 to 55 psi. In 1957, Schwinn received a patent for the "Westwind," which would become the main tire to be used on all their middleweight bikes. The Westwind proved to be very popular, especially the whitewall version, which every kid wanted to show off around town.

Thinner tires with more pressure meant less resistance on the road; this, along with the introduction of two- and three-speed hubs, made the middleweights a much faster vehicle.

The 1950s were also a time that stressed American values, and when Schwinn introduced the middleweight model called the "American" in 1955, the company highlighted that it was constructed of all US-made parts. Although Schwinn would make bicycles with some foreign parts, the "American" model reminded consumers that Schwinn was a US company, and proud of it.

THE CORVETTE

The 1954 Schwinn Corvette led the way into the new era of lighter-style middleweight bikes for kids. Sleek and sporty, the bicycle took its name from the popular Chevrolet automobile that launched in 1953. The car, in turn, derived its name from a small, speedy warship. The Schwinn Corvette exemplified the new lighter style and became one of the company's top sellers. The middleweights, like the Corvette, didn't actually weigh that much less (about 50 pounds), but they had the appearance of being sportier and faster.

To visually convey speed, some Corvettes came with a seat-tube decal depicting the checkered pattern of a race flag. Many bike enthusiasts appreciated the extras, like headlights and racks (for strapping on your lunchbox or schoolbooks). Some Corvettes came equipped with a front rack as well, manufactured of a light aluminum alloy by Mayweg in Germany. William Love points out in his book, *Classic Schwinn Bicycles*, that this "Schwinn-approved" carrier was typical of Schwinn's practice of buying

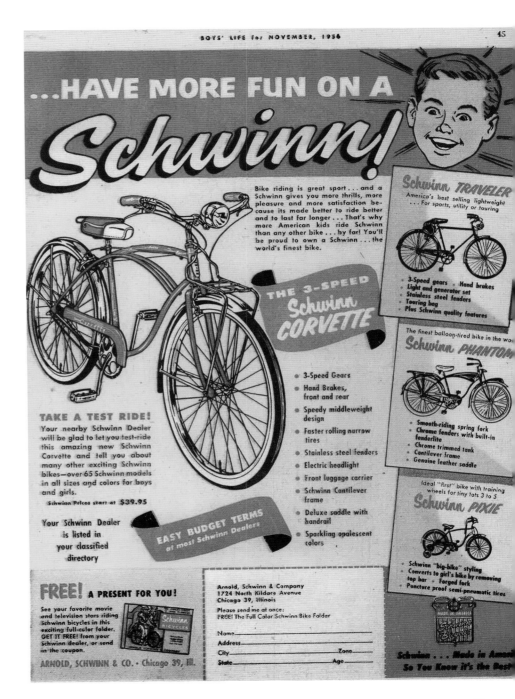

quality components from foreign manufacturers and then endorsing their quality by giving them the Schwinn seal of approval.

In addition to a single-speed coaster, the 1955 Corvette came with the option of having three speeds, controlled through a cable-operated hub. Two years after hitting the retail shops, the Corvette and other middleweights topped the sales charts, and by 1956 they outpaced sales of all other Schwinn lines.

Actor Clint Walker, star of the ABC-TV show *Cheyenne*, promoted the Corvette in an ad that read: "You'll be the trail boss on your block when you're riding a Schwinn. It's the best bike you can get . . . and it's made in America."

Other Corvettes offered the two-speed Bendix Automatic rear hub, and the Corvette line kicked it up a notch when it presented a five-speed derailleur model in 1961. Americans were not accustomed to this level of technology, and perhaps not quite ready for the new gear-shifting mechanism. The five-speed Corvette lasted only two years. In 1963, you could pick up a single-speed, 26-inch coaster for about $67, or a two- or three-speed for $77.

The December 1956 edition of Schwinn *Cycle News*. The Corvette no doubt found itself beside many a Christmas tree that year. Courtesy of the Bicycle Museum of America

The Corvette was manufactured in both boy's and girl's versions. In 1959, however, Schwinn dropped the girl's Corvette when it decided to direct more attention to tailoring certain models directly for young women, such as the Fair Lady and the Debutante. From the start, the Corvette simply had more of an association with typical boyish energy. Schwinn tacked on some stylish touches to the 1959 model, however: seats with an "S" logo on them, a spiffier chain guard, a high/low beam headlight, and white handlebar grips.

During their run, which ended in 1965, Corvettes mostly came in 26-inch frames, with a smaller number of 24-inchers being produced. In addition to the Corvette and heavyweight models that shifted to middleweight designs, there were the Spitfire, Bantam, Buddy, Catalina, Flying Star, Fiesta, Heavy Duti, and Barbie.

Taking its name from another big cat, the Tiger (1955–64) was not only a middleweight for its entire run, but also a middle-level in regard to price and accessories. Overall,

Spitfires advertised easy pedaling, a built-in tank with electric horn, a sturdy kickstand, a chain guard, a powerful headlight, and a comfortable saddle. Courtesy of the Bicycle Museum of America

The Tiger middleweight roared onto the scene with options of gear-shift hubs and coaster brakes. Courtesy of the Bicycle Museum of America

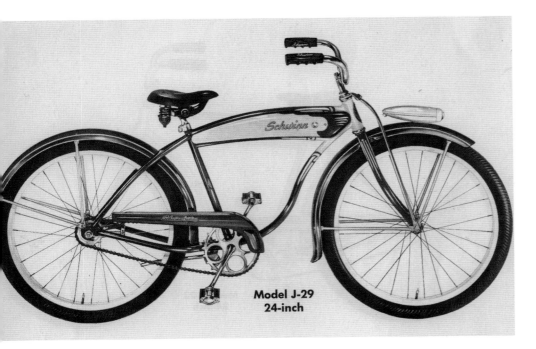

Model J-29
24-inch

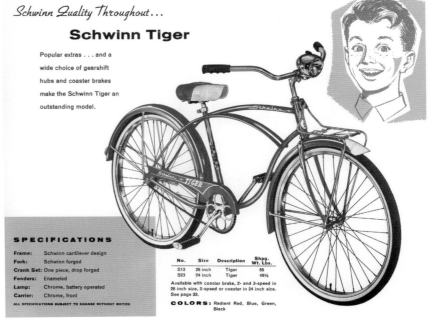

Schwinn Quality Throughout...

Schwinn Tiger

Popular extras . . . and a wide choice of gearshift hubs and coaster brakes make the Schwinn Tiger an outstanding model.

SPECIFICATIONS

Frame:	Schwinn cantilever design
Fork:	Schwinn forged
Crank Set:	One piece, drop forged
Fenders:	Enameled
Lamp:	Chrome, battery operated
Carrier:	Chrome, front

ALL SPECIFICATIONS SUBJECT TO CHANGE WITHOUT NOTICE

No.	Size	Description	Shpg. Wt. Lbs.
S13	26 inch	Tiger	55
S23	24 inch	Tiger	49½

Available with coaster brake, 2- and 3-speed in 26 inch size, 2-speed or coaster in 24 inch size. See page 33.

COLORS: Radiant Red, Blue, Green, Black

the Tiger packed more sportiness than luxury. Highlights included whitewall tires, a front rack, chrome fender, and sports pedals. Owners took pride in the special checkered decal on the seating tube and the Schwinn "Quality Seal." During its run, the Tiger came in one-, two-, and three-speed models. For a short time, there were smaller 24-inch Tigers and girl's models as well.

WILD-WEATHER RIDES: TORNADO AND TYPHOON

In 1958, Schwinn issued a bike that would appeal to those who could not afford the higher-end models. The Tornado was sold as "America's Whirlwind Bike Value," and it was a steal at $40. These were basic single-speed coasters but still built to last, available in three sizes, and in models for both boys and girls. For an extra ten bucks, a young person could get the deluxe version, which included a horn tank, rack, and headlight. After the Tornado met its demise in 1961, another weather-named bike came along in 1962: the Typhoon. The model became Schwinn's best-selling and longest-lived middleweight, finally dying out in 1982. Like the Tornado, the Typhoon was sold at a lower cost than some of the higher-end Schwinns. Deluxe editions came

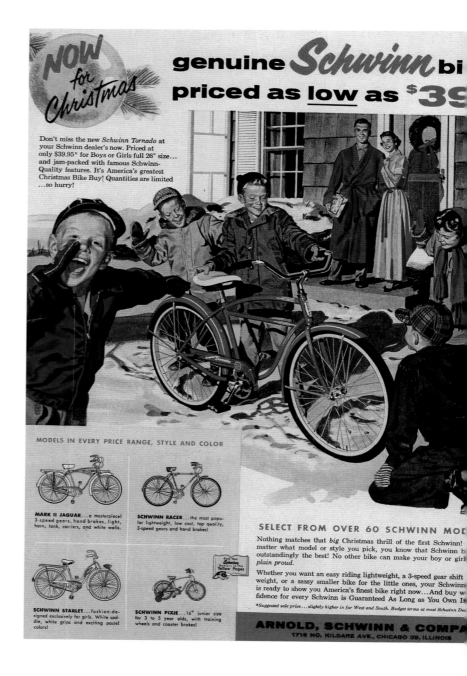

with a shiny chrome front carrier and chrome fenders, the rear one adorned with a small round reflector.

WHERE THE GIRLS ARE

While some models came in both boy's and girl's styles, Schwinn manufactured several bicycles just for the fairer sex, with the step-through frame to accommodate dresses and skirts. The Starlet was a heavyweight classic, which rolled off the production line in 1948. Schwinn ads declared the Starlet to be as "glamorous as your favorite TV stars," and "guaranteed to make any girl starry-eyed!" They came decked out with the popular horn tank, springer fork, electric headlight, chrome rims, and rear carrier. As with many bikes of the era, the Starlet name and logo was prominently printed along the chain guard. Some girls decorated

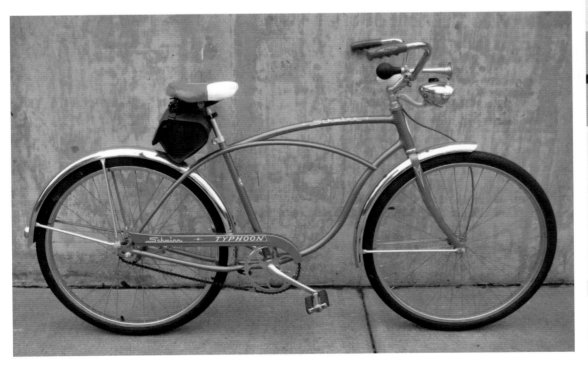

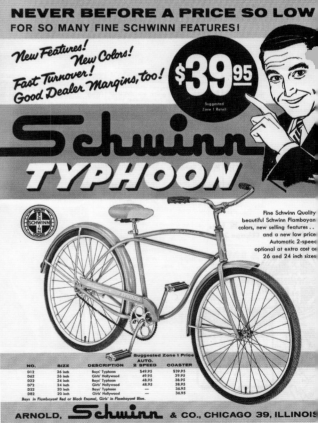

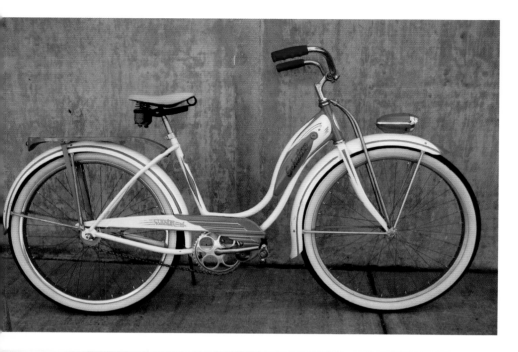

their rides with handlebar streamers and front baskets, and the pink version was a hit. Color options had a hint of romance to them: Windswept Green, Luscious Lavender, Summer Cloud White, and Holiday Rose.

While frames were produced in 24- and 26-inch sizes, they also produced a 20-incher for very young girls. In 1957, the Starlet shifted to a middleweight model. After a ten-year run, Schwinn came out with the Starlet II in 1959. This updated bicycle offered a rear luggage rack, chrome mudguards, and whitewall tires. The Starlet III followed in 1966 and lasted into the 1970s.

In a similar vein, the Hollywood was a deluxe model just for girls that started in 1938; like the Starlet, the name tied into the glamour of motion pictures and the fantasy of becoming a celebrity. Unlike the Starlet, the "Hollywood" name itself did not actually appear on the bike, only in the literature. Advertisements read: "Every bit as beautiful and graceful as the famous screen stars." William Love writes in his book, *Classic Schwinn Bicycles*, that the pre–World War II models had lacing at the rear wheel to keep skirts from becoming entangled in the spokes. The Hollywood was outfitted with expander brakes, springer fork, horn tank,

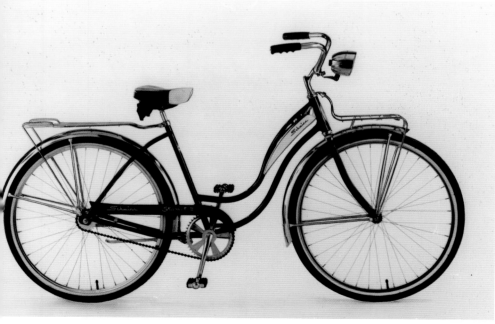

ABOVE: Schwinn produced several models designed just for girls—like the lovely Starlet. This 1955 model has been fully restored. Courtesy of Classic Cycle

The Starlet III. Courtesy of the Bicycle Museum of America

chrome-feather chain guard, a sleek Fenderlite, a big reflector, and whitewalls. Basically, the Starlet replaced the Hollywood in 1948, but the name returned in 1957 in a middleweight model that lasted until 1982.

THE DEBUTANTE AND THE FAIR LADY

When production ceased on the girl's Corvette in 1959, Schwinn had a coming-out party for its girl's Debutante, proclaiming that it was "All new . . . and just for you!" A debutante is a young woman making her formal entrance into society, and this bike was intended to convey that feeling of making a classy entrance into the adult world. The Debutante was "fashioned to steal the show

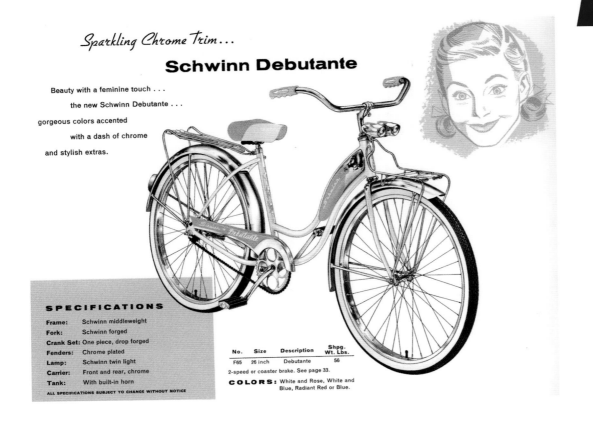

Sparkling Chrome Trim . . .

Schwinn Debutante

Beauty with a feminine touch . . .
the new Schwinn Debutante . . .
gorgeous colors accented
with a dash of chrome
and stylish extras.

SPECIFICATIONS

Frame:	Schwinn middleweight
Fork:	Schwinn forged
Crank Set:	One piece, drop forged
Fenders:	Chrome plated
Lamp:	Schwinn twin light
Carrier:	Front and rear, chrome
Tank:	With built-in horn
ALL SPECIFICATIONS SUBJECT TO CHANGE WITHOUT NOTICE	

No.	Size	Description	Shpg. Wt. Lbs.
F65	26 inch	Debutante	56

2-speed or coaster brake. See page 33.

COLORS: White and Rose, White and Blue, Radiant Red or Blue.

GEAR TALK

EXPANDER BRAKES: When pedaling backward on a coaster bike, expanders inside the rear hub push the brake shoes toward the inside surface of the hub. When the brake shoes rub against the inside of the hub, friction slows the bike down.

Whether it was product placement or coincidence, Hollywood was still promoting Schwinn bicycles in 1960. Alan Ladd of *Shane* fame poses with his bike on the Columbia Pictures backlot, while Jerry Lewis attempts to escape from Anna Maria Alberghetti in a scene from *Cinderfella*. Photos courtesy of Columbia Pictures and Paramount Pictures, respectively, via Steven Rea's *Hollywood Rides a Bike* collection.

wherever you go!" with its dual carrier racks (along with dual headlights), a streamlined horn tank, two-tone saddle, ornate seat-tube graphic, and teardrop-shaped rear reflector. Despite its glamour, the Debutante lasted only four years.

Also born in 1959, the Fair Lady was almost an identical twin sister to the Debutante. The premium middleweight featured stainless-steel fenders, teardrop rear reflector, the Schwinn Quality Seal, and an aluminum front double articulated rack. Even the seat was deluxe, with large chrome springs. While it was a sophisticated lady, the line ended after 1961, although the name reappeared on a girl's model of the 1964 Sting-Ray.

THE CO-ED

Priced at about $47, the Co-ed (1960–64) for girls maintained a trim "lightweight style" along with economy pricing. The machine came in black and white, as well as "flamboyant red" and "radiant blue." Although it offered the traditional quality Schwinn frame, this was considered a no-frills bike. It had chrome tires, but simple painted fenders and a plain block-letter logo. The Co-ed was a practical model for the young woman who was ready to attend to business—perhaps getting around to her classes on a college campus.

THREE-SPEED BIKES

On some three-speeds, the gears are in the hub of the back wheel, so unlike the derailleur, you don't see the gears—they're sealed inside. The three-geared hub was developed by Sturmey-Archer in Great Britain. The three-speed became popular in the United States in the 1950s, and by around the 1970s, the derailleur became the more-popular way to shift gears. By the 1980s, the three-speed was practically extinct, but some are still manufactured today for "Cruisers" and "Comfort" bikes. The system often uses a shift-lever- or twist-grip-style shifter connected to a Bowden cable (a flexible material used to transmit mechanical force or energy by the movement of an inner cable).

Chapter Six

THE FASTER SIXTIES AND SEVENTIES: THE MULTISPEED LIGHTWEIGHTS

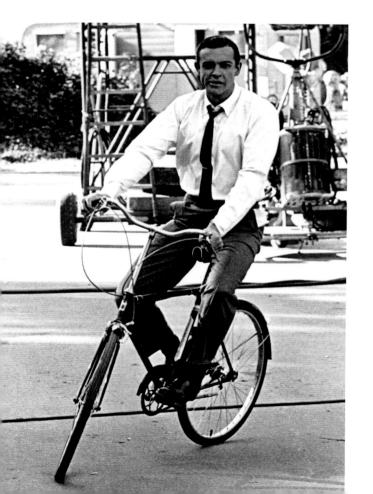

THE SIXTIES WERE A DECADE when life seemed to speed up. Just as go-go boots represented the high energy of the time, a new line of lightweight bicycles also captured the speed and vitality of the generation. As the 1960s started, America's interest in lower-cost lightweights with multiple speeds was just about to blast off.

At this stage, lightweight bicycles made up about 1 percent of the market, but racing and touring bikes were catching on with the public—especially in California, where the new ten-speed derailleur bikes were selling fast. Prior to this time, most bike purchases were for young adults and children, and the adult bicycle market made up a very small buying segment. Schwinn's first ten-speed bike was the Continental, rolled out in 1960. (A man selling a later-model Continental online listed its weight at about 36 pounds.) Again, tire width made a big difference, dropping from the 1.75 inches of the

As the super-cool James Bond, Agent 007, Sean Connery epitomized the glamour of the Swingin' Sixties. In this photo taken on a Hollywood backlot, he eschews his trademark Aston Martin for a more-practical Schwinn bicycle. Courtesy of Warner Bros. via Steven Rea's *Hollywood Rides a Bike* collection

middleweight tires to 1.25 inches. Schwinn sold the Continental for about $87, with the following ad copy:

> The finest sports equipment you've ever seen. The first really new bicycle in years. Rides so smoothly, so fast, so responsively, that you'll have to ride it to believe it. Smooth-action gear shift gives you 10 gear combinations for every riding situation.

While the Continental was faster and lighter than other Schwinns, other racing bikes from that same year were smoother, faster, about 10 to 15 pounds lighter, and more responsive, according to Classic Cycle in Bainbridge, Washington.

Around the same time the Continental hit stores, Schwinn also brought forth the Varsity, a lightweight eight-speed that took its name from a 1950s lightweight with the

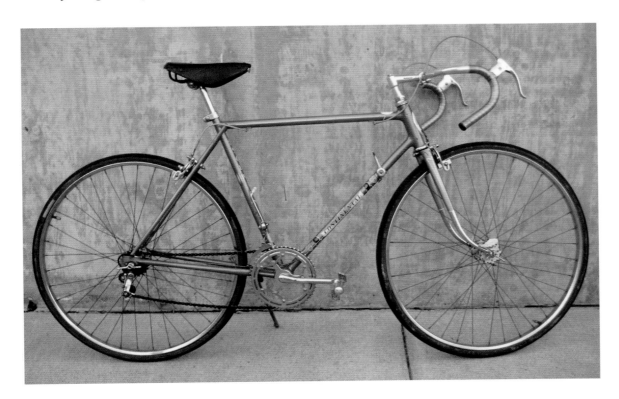

In the 1960s, the Varsity became the great American road bike, manufactured in greater numbers than any other derailleur bike. Courtesy of Classic Cycle

Bobby Sherman, 1970s teen idol, astride a Schwinn Varsity on the back of his 1971 album, *Getting Together*.

same moniker. While the Continental was popular, it was the Varsity (soon upgraded to a ten-speed) that paved the way for Schwinn's huge bike-selling boom of the late 1960s. Plus, the bright yellow, orange, and lime-green frames drew in customers.

At first, the early Varsity provided a front derailleur lever attached low on the seat post, which some nicknamed "the suicide shifter." Jay Pridmore and Jay Hurd wrote in their book, *Schwinn Bicycles*, that the Varsity had to overcome some problems surrounding the ease of operation with the derailleurs and the performance of the rear sprockets and freewheel before it would become one of America's most beloved bicycles.

Schwinn said that the Varsity taught America how to ride a touring bicycle. Touring bikes were intended for pleasure and adventure, rather than sport or commuting. For

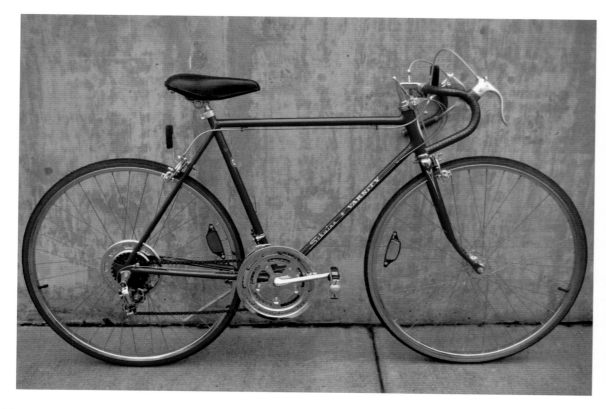

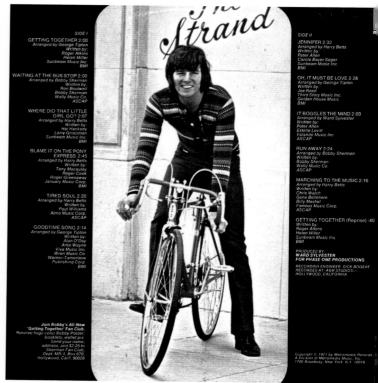

those taking up bicycle touring, a trip could range from a few hours to a single day to several weeks, or longer.

Author and bicycle enthusiast Tom Shaddox wrote online that although the Varsity held the distinction of being one of the heaviest lightweights ever built, it was manufactured in greater numbers than any other single model of a derailleur-geared bike in the world. Shaddox called it the single most significant American bicycle, stating that this was the bike that turned the semi-interested into enthusiasts. People liked that the bike—which first appealed to teens, and then to an adult market—was durable, and could withstand wear and tear.

A growing wave of adults embraced pedal power, and once again bicycling became a nationwide phenomenon. Promotion helped to fuel the frenzy and was key to the Varsity's success. Schwinn found that advertising in *Boys' Life* magazine helped them reach one large vital market segment—older teenage boys. In 1971, pop singing star Bobby Sherman was pictured on a Varsity on his album, *Getting Together*. That same year Schwinn sold 1.2 million units. In 1974, Coca-Cola mounted a nationwide "Half Million Dollar Bicycle Giveaway," giving away five thousand Varsity ten-speeds. Radio ads from the year declared that 1974 was "The Year of the Bike."

Schwinn manufactured the Varsity through a unique process called "electro-forging." It involved taking large coiled rolls of steel strip and rolling and welding them into tubing. Selling at about $70, the Varsity came equipped with a French-made Ideale racing seat and caliper brakes. In 1964, the Continental sold for $80; the Sierra, for $90; and the Collegiate, for $57.

GEAR TALK

CALIPER VERSUS COASTER BRAKES: A caliper is a type of rim brake that uses a mechanism attached to the bike's frame involving two hinged legs with brake shoes on the end. When the brake handle is squeezed, a cable draws the calipers together, clamping the brake shoes against the rim to stop the wheels. A coaster brake has a rear hub that brings a bike to a stop by pedaling backwards, but it also lets a bicycle roll forward without pedaling—in other words, it lets the bike "coast." Coaster brakes were invented in the 1890s, but remain popular today.

Drop handlebars were a standard feature on most lightweights. The 1965 Schwinn catalog said that the drop handlebars "make an astonishing difference in riding efficiency, adding power, speed, and endurance most people never knew they possessed. It is this thrilling experience, a new discovery for most of us, that has led to the great popularity of sports bikes and much of the public's interest in cycling for exercise and recreation."

Drop bars allow the body to lean forward at about a 45-degree angle when the hands are on the upper part of the bar, and a little lower when the hands are on the "drops," or lower bar. This "crouch" position cuts down wind resistance and increases the

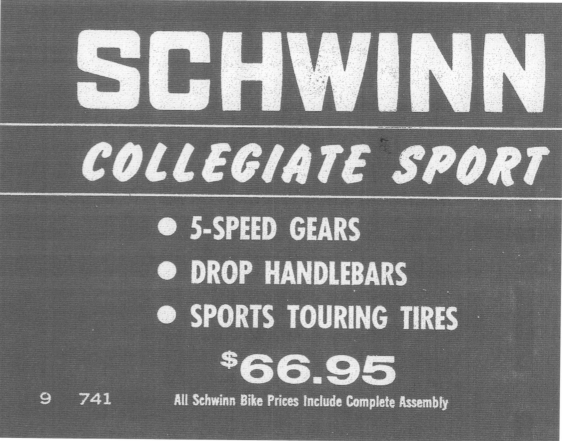

rider's leverage on the pedals so he can go faster and further with about half the effort required in the upright or erect position.

Because dropping to the lower hand position helps with better aerodynamics and allows wind to pass over the back, riders generally assume this position when at higher speeds.

In 1967, Schwinn introduced easy-to-reach controls for shifting gears called the Twin-Stik, which operated with two levers attached just below the handlebar stem.

The Varsity had a long run of about twenty-five years, into the mid-1980s. Today, however, many bike collectors tend to criticize the Varsity because of its weight problem;

FOR THE OLDER CROWD

Looking to get its bikes into the hands of as many age groups as possible, Schwinn dreamed up an adult three-wheeler. Called the Town & Country and sold in one-, two-, and three-speed versions, the three-wheeler provided an extra-large basket in the rear, making it ideal for shopping excursions.

Courtesy of the Bicycle Museum of America

A Schwinn dealership was a source of pride for many bicycle retailers in the 1960s and '70s, and Schwinn encouraged competition among dealers by establishing the "1,000 Club" in the early 1950s, for any dealer who had sold 1,000 Schwinns in a year. By 1968, 450 dealers had joined the Club. Courtesy of the Bicycle Museum of America

the bike was about 40 percent heavier than similar competing bikes at the time. In the 1970s, Schwinn began to import bikes made in Japan to meet demand, and these Schwinn imports were lighter and easier to operate than the American-made versions.

Schwinn kept up a hot streak in the early 1970s, and it didn't take long before the firm had forty-eight different multi-geared derailleur lightweights on the market. Schwinn even provided lightweight bicycles for the 1972 Munich Olympics, including twenty-eight custom Paramounts. In his book *Bicycles in American Highway Planning*, Bruce D. Epperson wrote that the great ten-speed bicycle boom really reached its maximum level between 1969 and 1973. "Domestic sales shot up from 35 per 1,000 persons

TAKING OFF ON A TEN SPEED

"When I was a boy, I loved to ride. Late-night rides with no lights were fun freedom for a pre-teenager. As the rides got longer, I realized a single-speed bike was just not enough to get where I wanted to go. . . . The local swap meet became my friend as I bought, fixed up, rode, and resold many ten-speeds. They were all Schwinns, as that was the popular bike of the time. Most were Varsitys, some with the early eight-speed drivetrain. Some were Continentals, with nicer pieces and better brakes. And finally, a brand-new white Varsity that I sold to a friend the second I got my driver's license. There were some great memories that got lost with the roar of motorcycles and hot rods."

—TURBO BOB'S BICYCLE BLOG

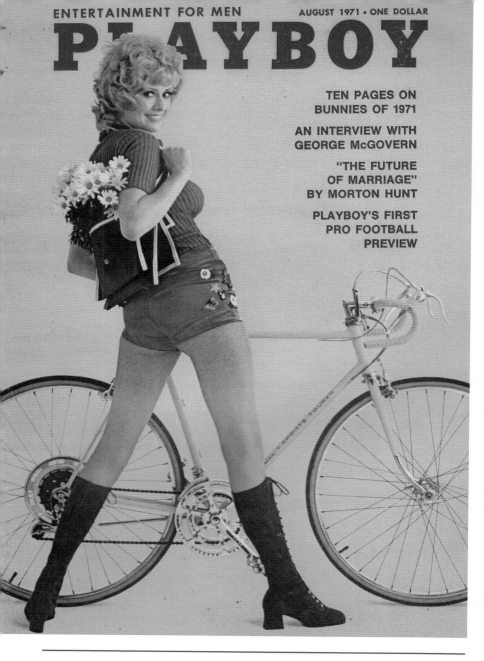

in 1969 to 72 [per 1,000] in 1973. Almost all of this was in the form of adult, lightweight, multi-geared bicycles."

Other lightweight touring models popular in the 1970s included the World Voyageur, Voyageur II, Traveler, Collegiate, Volare, Breeze, Sprint, Sierra, Caliente, the Sports Tourer, and Super Sport. The 1970 Suburban was geared to attract older riders with is upright handlebars and wider seat. Some Collegiates had upright handlebars as well, along with five speeds.

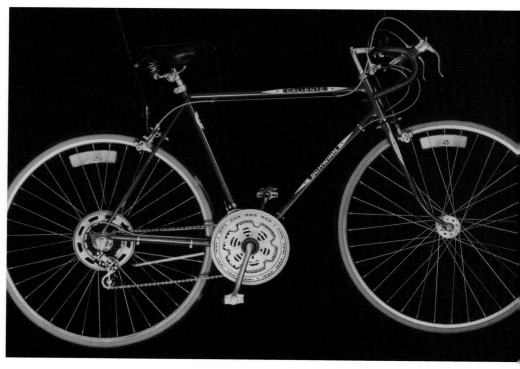

The Schwinn Caliente, one of Schwinn's lightweight touring models from the 1970s. Courtesy of the Bicycle Museum of America

In the 1970s, ten-speed bikes were part of the culture, and a Schwinn Sports Tourer was even featured on the cover of *Playboy* magazine, although spandex cycling gear had obviously not yet come into vogue. Courtesy of the Bicycle Museum of America

A BELOVED VARSITY: BRINGING A BIKE BACK TO LIFE

For his thirteenth birthday in 1978, Rob McLewee went down to his local bicycle store in Bel Air, Maryland, to pick out a new ten-speed. For kids in his suburban neighborhood, bikes provided the main mode of transport, and he was determined to get a Schwinn. Although his best buddy had a Sting-Ray, McLewee wanted to join the swelling ranks of young people with ten-speeds. He picked out a Flamboyant Red Varsity. He loved the bike throughout his teen years, but as time passed, he stored it away in a crawl space at his parents' house, where it wound up rusting away.

Thirty-three years later, McLewee felt a pang of nostalgia for his glory days, zooming around Maryland on his Varsity. After several months replacing parts, along with painting, polishing, and oiling, McLewee had fully restored his old Varsity from decades past. He took a remarkable photo of the refurbished Schwinn showing him and his adult sister on a tiny tricycle. The photo exactly duplicates the setup of another photo they took thirty-three years earlier, when McLewee first bought his Varsity. Today, McLewee also has a 2013 Schwinn 4 One One, the Vantage F1 Hybrid, and two Schwinn Rocket mountain bikes.

Photos courtesy of Rob McLewee

Riding a Schwinn in the 1970s was a way to fight pollution and skyrocketing gas prices. Courtesy of the Bicycle Museum of America

OPPOSITE: Built in Japan, the Le Tour helped to maintain adult interest in multispeed lightweights. Courtesy of the Bicycle Museum of America

In 1973, an oil embargo in the United States, imposed by the Organization of Arab Petroleum Exporting Countries (OAPEC), led to fuel shortages throughout much of the decade. At the same time, Americans were more concerned about the environment than ever before. The first Earth Day was held on April 22, 1970, and President Richard Nixon began the Environmental Protection Agency the same year. In the 1970s, the federal government passed major amendments to the Clean Air Act and Clean Water Act to further limit air and water pollution. With concerns over gas availability and the environment at an all-time high, American adults turned to the bicycle, and a fascination with all things European (like bicycling) helped to fuel the bike craze.

Schwinn tried to meet consumer concerns over the gas shortage and pollution, rolling out the Metro-Cycle in 1978. Instead of taking the car, riders could use this simple three-speed coaster bike with front and rear lights to carry groceries or baggage because it came with two folding wire baskets attached in the back. The

advertisements drove home the point that these were gas savers; priced at about $140, they cost about as much as "ten tanks of gas."

In some ways, Schwinns were starting to grow out of fashion among adults in the 1970s, as European and Japanese bikes captured more and more of the market. Plus, Schwinn still struggled with the image of being a kid's bike. The Le Tour helped Schwinn to steer more buyers in their direction. Advertised in *Sports Illustrated*, this was Schwinn's first bicycle to be built in Japan, but the company made sure that the Japanese manufacturers met its high standards. A 1974 edition of *Bicycle* magazine wrote: "The all-Japanese

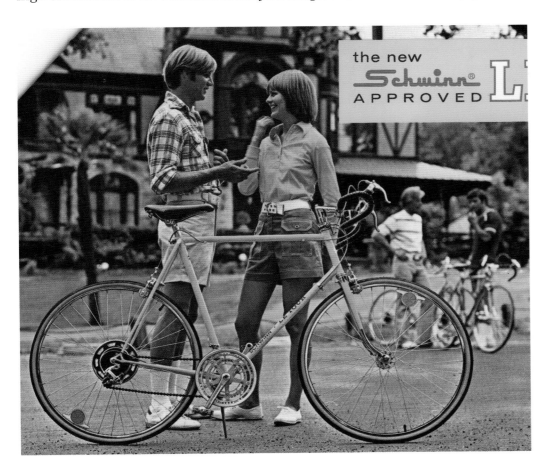

GEAR TALK

CRANKSET: The sprockets (or chain wheels), crank arms, and pedals.

GEAR TALK

DERAILLEUR: The device that changes gears and speeds by moving the chain from one sprocket to another. One is on the front crankset and one is on the rear wheel.

Le Tour is an example of careful examination of the market: a good-performing, moderate-weight, reasonably priced, durable and reliable ten-speed." Light and stylish, this racing bicycle took off in terms of sales. Although made abroad, the quality of the all-steel construction with metal shifters and derailleurs made them reliable and durable, although some argue that Japanese steel had a lesser quality compared to American steel. One Le Tour fan wrote online: "The strong metal used for the frames

OPPOSITE TOP: The summer after *Star Wars* came out, Mark Hamill was hugely popular, having played the lead of Luke Skywalker. In 1978, he can be seen speeding along on a Schwinn ten-speed in the adventure-comedy *Corvette Summer*. *Breaking Away*, which would come out the following year, became a breakaway hit that encapsulated the thrill of bicycle racing. Courtesy of MGM via Steven Rea's *Hollywood Rides a Bike* collection

Bicycle commuting started to become fairly common in the 1970s and is still popular today, although you seldom see cyclists wearing suits these days. Courtesy of the Bicycle Museum of America

Road and race bikes remained popular into the early 1970s, but the trend began to change by the mid-1970s. Courtesy of the Bicycle Museum of America

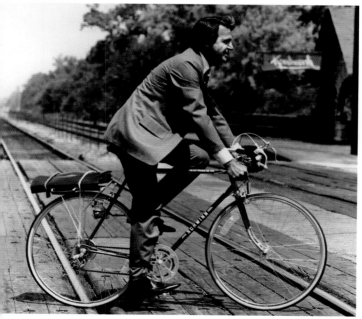

could take a sustained load without making the bicycle ride slower." Schwinn developed strong relationships with Japanese manufacturers, including Shimano, which helped create the Twin-Stik.

Sales on the Le Tour started to sag as the bicycle market as a whole began a downhill slide in 1975. According to Pridmore and Hurd in *Schwinn Bicycles*, Schwinn sales dropped from 1.5 million in 1974 to fewer than 900,000 the following year. At the start of the boom, as many as 30 percent of the ten-speeds sold in the United States were Schwinns. By the end of the boom, Schwinn's share was less than 15 percent.

WHAT SIZE IS RIGHT FOR YOU?

The 1967 Schwinn catalog explained how to choose a bike that's right for your body. Bike sizes are identified by wheel sizes—26- or 27-inch wheels for full-size or adult models; 24- and 20-inch for junior sizes and Sting-Rays; and 16-inch for beginner's models. Full-size lightweight styles come in several frame sizes—from 19-inch frames for riders with leg lengths of 29.5 inches to 35 inches, and 23- or 24-inch frames for riders with leg lengths of up to 38.5 inches. Leg length is measured from crotch to floor, while wearing flat-heeled shoes.

GEAR TALK

FREEWHEEL: A mechanism on the rear wheel that lets it turn faster than the pedaling, transferring power from the pedals to the wheels. Without it, pedaling would take much more effort and be much more exhausting. The freewheel allows the pedals to remain stationary while the bicycle is moving.

Interlude

VARIATIONS ON A SCHWINN

HERE ARE SOME OF THE MORE UNLIKELY CYCLES THAT ARE EITHER INSPIRED BY OR MADE BY SCHWINN:

Many Schwinns have developed from the ideas of bicycle enthusiasts who are hands-on and mechanically inclined. Sting-Rays, BMX, and mountain bikes all grew from the imaginations of those who were willing to take out some tools and build something new. Their ideas caught on and had mass-market appeal. Not all self-made bikes will sweep the nation, but they can be fun and interesting all the same. The hybrid pictured above is a true Frankenstein of parts. Using an original Schwinn frame, the bike combines a springer fork, mock tailpipes, a massive back wheel and a smaller front one, a fat saddle, small carrying rack, dual headlights, and extended front guard. Two methods of steering are offered: either with the unique curved handlebars or via a wheel. It doesn't look very easy to ride, but it's an unforgettable attention-getter. Courtesy of the Bicycle Museum of America

To celebrate its one hundredth anniversary back in 1995, Schwinn not only produced a reproduction of the iconic Black Phantom cruiser, it also issued a limited number of commemorative Black Phantom bar stools. The front legs were actually handlebars, and the seat was genuine leather. Unfortunately, the tank did not come with the horn. Because only a few hundred were manufactured, the stool is a highly sought-after rarity, and fetches about $850 on eBay. Courtesy of Classic Cycle

This Pee-wee Herman–themed bike shows how a two-wheeler can be decked out to the extreme with horns, toys, lights, baskets, decorations, a radio, and more. Courtesy of the Bicycle Museum of America

Some Schwinns were adapted to provide thrills at the circus. The Typhoon pictured here from the late 1950s was outfitted with grooved 26-inch wooden wheels so acrobats could glide across a high wire, astonishing the crowds below. The handlebars on this basic cruiser could lock into a fixed straight position to help ensure that the daredevil rider could proceed without a tumble. Courtesy of the Bicycle Museum of America

Bike Works NYC created this Schwinn Legacy Scotts mower for a TV show in 2015. No word on whether it actually worked, although other bicycle/mower hybrids are known to exist. Courtesy of David Perry at Bike Works NYC

The one-wheeled wonder, the unicycle, will never be a blockbuster in terms of sales, but many young people have an interest in them as a fun challenge. It takes incredible balance and coordination to master riding a unicycle. Schwinn has made a few different versions along the way. Pictured here, a paperboy delivers to his neighborhood route—certainly not your typical way of distributing the local news. Courtesy of the Bicycle Museum of America

A barbershop quartet astride a custom-built Schwinn quad in front of the Hills Brothers Coffee Garden at Disneyland in the 1970s. Courtesy of the Bicycle Museum of America

At one time Schwinn offered branded merchandise—call it Schwinn swag—from cigarette lighters to jewelry. Courtesy of the Bicycle Museum of America

Designed as a family game that adults and children can play together, Schwinn: The Biking Game from Education Outdoors both educates and entertains. The game provides information about the history of bikes, bike parts, and bike safety, while encouraging players to share their fondest bike memories and get outside and ride! The object of the game is simple: to get home from the parking lot, moving pieces that are all Schwinn bikes, from current models to the old classics. If you want to learn even more about bikes through game play, Education Outdoors also makes the Build-a-Bike card game, where players race to assemble the largest fleet of Schwinn bikes. Players need to build a bike by collecting cards for each component (tires, frame, seat, handlebars, helmet), earning points for each (for example, eight points for a carbon-steel frame, three for an aluminum frame). The player with the highest point value wins. Both games are currently available through Amazon. Courtesy of the Bicycle Museum of America

The Bee Gees on their Schwinns, on the set of the film version of *Sgt. Pepper's Lonely Hearts Club Band* in 1978. Photo by Eddie Sanderson, reprinted with permission

Chapter Seven

THE STING-RAY STRIKES

AROUND THE SAME TIME that lightweights were gaining traction in the early 1960s, another phenomenon in the biking world was brewing on the West Coast—and once again, Schwinn would lead the pack. It seemed natural for bicycling trends to originate in California, with its good weather, great roads, and beautiful scenery. In these sun-drenched lands that gave birth to hot rods and drag races, attitudes about what bicycles could look like were changing. For some kids, heavier bikes were losing their appeal. Now bike fans were getting more creative. In Los Angeles, young people were buying up the smaller 20-inch frames from old Schwinns and refitting the frames with longhorn handlebars, also known as butterfly-type bars or ape-hangers, adopting their look from early chopper-style motorcycles. The handlebars gained different nicknames in different towns; Chicagoans called them angle bars, and Seattleites dubbed them monkey bars.

"I've got you under my Schwinn." California's sunny weather made it the perfect hotbed for new ideas in the cycling world. Courtesy of the Bicycle Museum of America

Margaret Guroff's book, *The Mechanical Horse: How the Bicycle Reshaped American Life*, quotes a bike shop visitor seeing these handlebars for the first time: "They rose up so fantastically tall they suggested the antennas of Martian insects." They also customized the frames with elongated seats that were originally made to play European bike polo. The polo saddles would soon become known as banana seats. Persons, the oldest bicycle seat manufacturing company, had produced a large inventory of these seats in the early 1960s that were going unused in a warehouse. Suddenly, demand for these saddles swelled.

Tricked out with other accessories, these modified two-wheelers took their style cues from the rising motorcycle culture of the time. Kids called them "pig bikes." (They may have gotten the nickname because Harley-Davidson motorcycles were called hogs.)

The classic Sting-Ray in profile. Courtesy of the Bicycle Museum of America

Sting-Rays were built to do tricks like "popping a wheelie," demonstrated at a Schwinn dealership in the 1960s. Courtesy of the Bicycle Museum of America

SCHWINN STING-RAY®

8-6
al Red, Sky Blue
-6
with Yellow Trim

"That's not a bike, it's my Sting-Ray!"

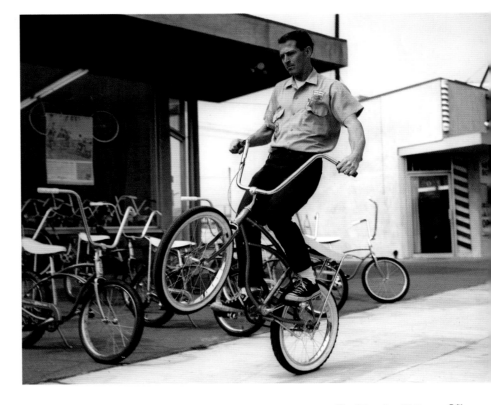

They gained other slang names as well, such as muscle bikes, high-risers, spyder bikes, banana bikes, and wheelies. They got the wheelie name because they were designed just right for leaning back and "popping a wheelie," which meant pulling your handlebars back so your front wheel would come off the ground. The bike would then speed along on just its back wheel. Pig bikes were also pretty great for slamming on the brakes and skidding to a halt. All in all, these bikes were the ultimate in cool.

"Ahhhh, the Schwinn Sting-Ray. Our first real bicycle at seven years of age was a Sting-Ray in blue, with a five-speed gear shift on the top tube, banana seat, coaster brake, sissy bar, and baseball cards fitted between the spokes. That Sting-Ray sparked a lifelong love affair between the bicycle and us."

—CHUCK SUDO, THE CHICAGOIST WEBSITE

Al Fritz was a longtime employee at Schwinn. After World War II, he had gotten a job with the company as a welder, working his way up into management. As the story goes, a West Coast sales manager called him one day after seeing more and more kids on pig bikes. He told Fritz, "Something goofy is going on." When Fritz heard how young people in Orange County were putting so much energy into modifying these cycles, he realized there could be a market for a version that was already made and ready for sale. Gathering various parts, Fritz assembled the first prototype of the Sting-Ray at Schwinn's Chicago headquarters. Although some in upper management first scoffed at the design, they found the prototype easy to pedal and fun to ride. Plus, it had the unique ability to turn a sharp corner. Still, few thought it would be a blockbuster. Even Frank Schwinn, the company's president, had his doubts, thinking sales would be mediocre at best.

In an interview on NPR just after Fritz's death in 2013, his son said, "He got universal disapproval for the idea. People thought it was a stupid idea. But at the time, my dad was vice president of engineering research and development, and he certainly had the clout to push through a concept, even if he was the only one that believed in it."

After putting considerable research into possible names, Fritz came across a photo of a stingray, and decided that the sea creature's swooping fins embodied the coolness of

this new bike. In 1963, after a bit of persuasion, Schwinn decided to give the new style a go, and the company began churning out Sting-Rays. Priced at about fifty bucks, the Sting-Ray became the best-selling bike in Schwinn's history, and lasted through the early 1980s. (Not wanting to miss the trend, other bike manufacturers, such as Huffy, started cranking out similar pig-style bikes around the same time.)

Announced to the world in the middle of 1963, the J38 Sting-Ray was advertised as an exciting, new thrill ride: "An eye-popping new look and a revolutionary new design that puts more fun in cycling. Unbelievable maneuverability based on a unique short

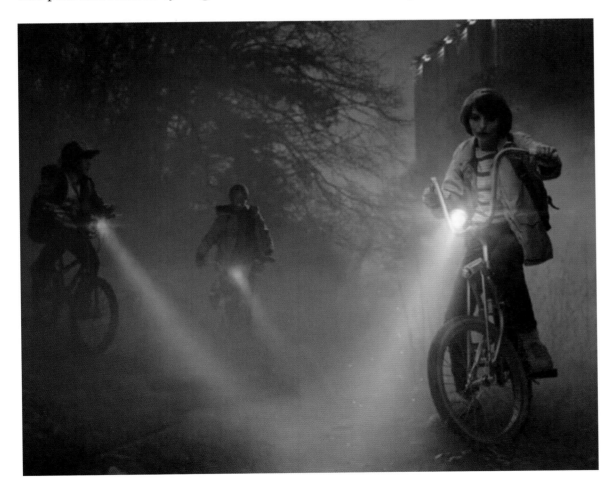

turning radius. A 20-inch cantilever frame combined with special equipment to form an unusual 'full-size' bicycle." Along with the butterfly handlebars and Solo Polo saddle, another signature design detail was the "sissy bar." Short for "sister bar," this support, which had a squareback design at this stage, helped to hold up the banana seat and served as a small passenger backrest. With a Sting-Ray, a sister, brother, or friend

In the mid-1960s, *The Munsters* towered in TV ratings. Eddie Munster, played by Butch Patrick, received his own custom-made Schwinn using a Sting-Ray frame as the template, but with lengths of welded steel chain, black coffin-style upholstery on the seat, an antique brass tail lamp, and a clear round Plexiglas windshield mounted to the handlebars, complete with a spider in a spiderweb design. The adult Butch Patrick stands here with his souped-up Schwinn. Courtesy of Butch Patrick

could hop on board and ride along on the same seat, although this endeavor could be pretty precarious. Still, letting a girl jump on the back of your banana seat for a ride was a thrill for a preadolescent boy who wanted to get closer to a crush.

The Sting-Ray also provided a knobby or studded rear tire that could handle trails and rougher terrain, as well as city streets. It was fatter than the front tire, at 2.125 inches (compared to the standard 1.75-inch Westwind brick tread in the front), and its high traction made it perfect for quick starts. This type of studded tread in the back was a precursor to the wheels that would be used on mountain bikes or off-road BMXs in the future. The first two years the wheels had thirty-six spokes, reduced down to twenty-eight thereafter. The colors were as bold as the bike itself—Flamboyant Red, Flamboyant Lime, and Radiant Coppertone.

> "You were the bomb if you owned a banana-seat bike; just like today, if a young person has a car first, everyone wants to mooch a ride."
>
> **—SUSAN S., PINTEREST**

With an affordable price of just over $50, the cutting-edge cycle proved to be a runaway hit. Typically, Schwinn might expect yearly sales of about 10,000 for a new bike, but in less than a year, the Sting-Ray sold 45,000 units, and the company said it could have sold more if it hadn't run out of stock on 20-inch tires from their supplier, Uniroyal. Within two years, the Sting-Rays and bikes in that style accounted for about 60 percent of all bike sales in America.

When 1964 rolled around, Schwinn kicked things up a notch, presenting a deluxe version of this two-wheeled dream machine for children. Costing about seven bucks more than the standard, the J39 model sported chromed rear and front fenders, whitewall tires, and the "Deluxe Sting-Ray" name inscribed on the chain guard. The new-edition banana seat was also cushier, with a deep-tufted design that became a Sting-Ray trademark.

That year, Schwinn also tailored a Sting-Ray just for girls called the Fair Lady (repurposing the name from a 1959 girl's bike). It featured a step-through frame, which they

Schwinn wasn't leaving girls out of the Sting-Ray craze. The Fair Lady had the Sting-Ray flair, but with a few feminine touches. Courtesy of the Bicycle Museum of America

said was good for a daughter, mother, and even grandmother. A white flower-trimmed basket on the front added a finishing highlight, considered "ladylike" at the time.

The 1970 Schwinn catalog touted a Sting-Ray bike called the Stardust that was "perfect for mother and daughter." The company sold it as a "shopper's bike" with a removable flower-trimmed shopping basket with handles. The chrome-plated basket carrier on the front handlebars had a quick-release mechanism to make shopping excursions easy.

In 1965, those who were not satisfied with simply deluxe could order a "Super-Deluxe" version. A high-hooped sissy bar replaced the squareback version. One throwback was the addition of a 20-inch springer fork. Sting-Rays were now available in one, two, or three speeds. Some models came equipped with a new Schwinn slick rear tire, which

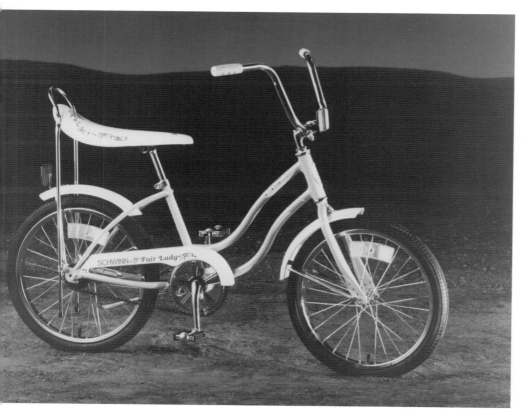

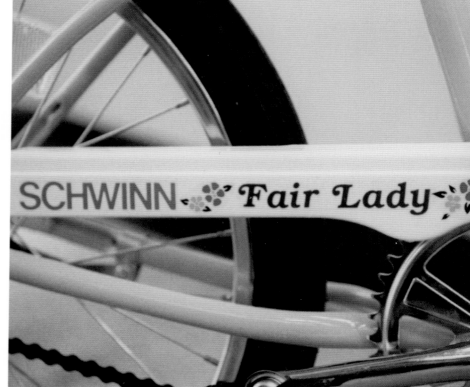

...for the young in heart

YOU NEED IS HER

Schwinn

Schwinn
STARDUST ™
GIRL'S LIGHTWEIGHT STING-RAY®

Perfect for mother and daughter. Designed with the ladies in mind...the young in heart. Lightweight styling including lavish chrome trim, MAG type sprocket, plus the new chrome plated basket carrier and removable flower trimmed shopping basket with carrying handles.

$**61**⁹⁵*
with coaster brake

3-speed Stardust $71.95*

*Zone 1 suggested list price.

SCHWINN BICYCLE COMPANY

The Stardust was marketed to young women and their mothers. Courtesy of the Bicycle Museum of America

Actress and singer Doris Day was an avid cyclist who did a number of advertisements for Schwinn. In the movie *With Six You Get Eggroll* from 1968, Day took a spin on a classic Sting-Ray. Courtesy of National General Pictures via Steven Rea's *Hollywood Rides a Bike* collection

The Slik Chik was another popular entry in the girl's category of Sting-Rays, adorned with a modest front basket when it debuted in 1966. Courtesy of the Bicycle Museum of America

A "Silver-Glow" saddle became standard on deluxe editions. Some of the Sting-Ray Fastbacks featured the distinctive Ram's Horn handlebars, featured in the ad at the lower right. Courtesy of the Bicycle Museum of America

was similar to ones seen on drag racers and track cars. The 1965 catalog praised these wheels, sold under the brand name "Slik," for having more road surface than any other bike tire. They typically gave more traction than grooved tires on dry roads, but could be slippier under wet conditions.

To add some oomph to the gear-changing, Schwinn created a prominent stick-shift control lever mounted on the top bar. Called a "Stik Shift," it was available on a standard three-speed and on the new Fastback, which featured a five-speed derailleur. The frame was a 20-inch diamond style rather than a cantilever. In

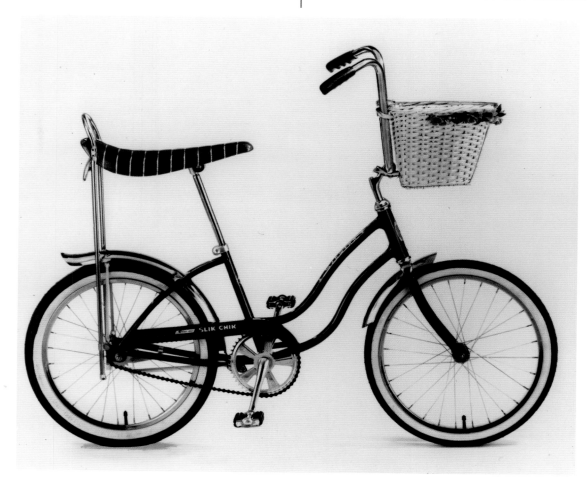

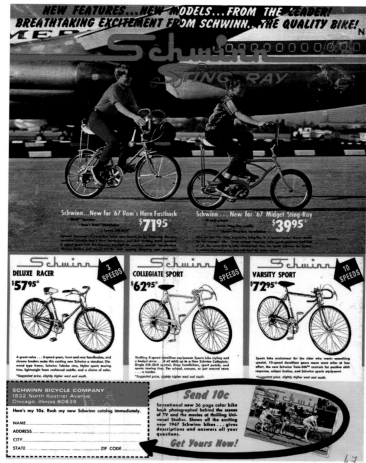

1967, the Fastback line received a Ram's Horn edition. Although it was not a hot seller at the time, lasting only about a year, today's collectors desire them for their distinctive handlebars, which were high up and curved back around like horns. The Fastbacks now also came with all-steel "rat-trap" pedals, which had hard edges to keep feet from slipping. The Fastback line was popular, continuing until 1976.

In 1967, Schwinn also rolled out Midget Sting-Rays for wee ones. The bikes offered 16-inch wheels and smaller frames. The Lil Tigers with 12-inch wheels suited even tinier tykes.

THE GREAT KRATES

To fuel its sales engine, Schwinn needed to invent new and more thrilling versions of the Sting-Ray. In 1968, it did just that with the introduction of the now-classic Sting-Ray Krate series. Whereas the Sting-Rays took their design from stock muscle cars, the Krates were inspired by dragsters. Sold as the "flashiest Sting-Rays ever designed," the Krates drew on the past as well, equipping them with spring-suspension front forks, just like many of the old heavyweights. They also featured seat shocks and front drum brakes. While the back wheel stayed at 20 inches, the front wheel was shrunk down to just 16 inches, and was covered by a short fender. The smaller wheel up front definitely gave the Krates a dragster feel. A racing stripe (and Schwinn "S" logo) on the banana seat added another race-car touch. Although they sold one-speed coaster-brake models, the Krates with the prominent five-speed Stik Shifts

This ad for the 1963 20-inch Buddy showed Schwinn's continued interest in reaching out to the youngest riders. Courtesy of the Bicycle Museum of America

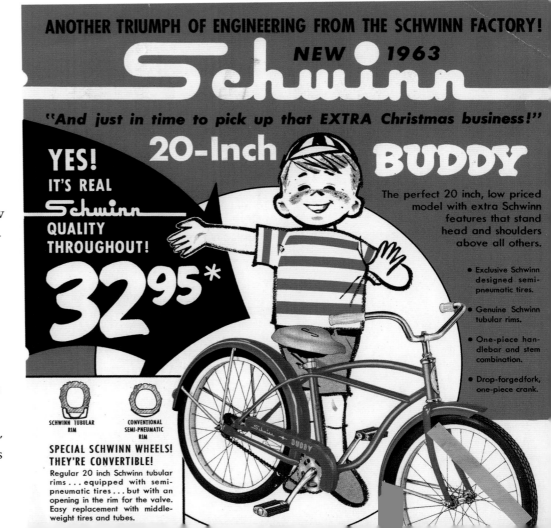

ANOTHER TRIUMPH OF ENGINEERING FROM THE SCHWINN FACTORY!

NEW ● 1963

Schwinn

"And just in time to pick up that EXTRA Christmas business!"

20-Inch **BUDDY**

YES! IT'S REAL *Schwinn* QUALITY THROUGHOUT!

32⁹⁵*

The perfect 20 inch, low priced model with extra Schwinn features that stand head and shoulders above all others.

● Exclusive Schwinn designed semi-pneumatic tires.

● Genuine Schwinn tubular rims.

● One-piece handlebar and stem combination.

● Drop-forged fork, one-piece crank.

SCHWINN TUBULAR RIM CONVENTIONAL SEMI-PNEUMATIC RIM

SPECIAL SCHWINN WHEELS! THEY'RE CONVERTIBLE!

Regular 20 inch Schwinn tubular rims . . . equipped with semi-pneumatic tires . . . but with an opening in the rim for the valve. Easy replacement with middle-weight tires and tubes.

mounted on the center bar were among the coolest and most coveted. Kids paid a price to be cool, however; five-speed shifters cost about $100 compared to about $80 for the coasters. On December 10, 1968, Schwinn managers gathered to have their photo taken with an Orange Krate. They celebrated a major benchmark, having for the first time sold one million bikes in a single year.

Along with the Orange Krate (in Kool Orange), other styles zoomed into the market the following year—the Apple Krate in Flamboyant Red, the Lemon Peeler in Kool Lemon, and the Pea Picker in Campus Green.

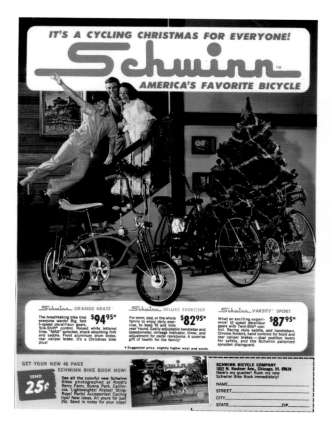

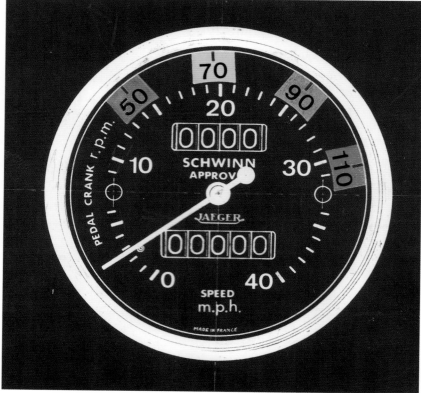

In 1970, the plain white Cotton Picker came along (but didn't sell very well), followed by the Grey Ghost, which also left buyers unimpressed. The Grey Ghost, however, has become a rarity, hotly sought after by collectors today.

The six Krate models generated big sales for about six years, until fading in the early 1970s. The Krates suffered a major blow in 1974 when the Consumer Product Safety Commission outlawed this type of stick shift on bikes. Too many kids were getting impaled in the groin when they jumped off or popped wheelies.

The Schwinn Lemon Peeler. Courtesy of Classic Cycle

The Grey Ghost was not a hit at the time, but today it's highly desired among collectors. Andy Caro refurbished this one, which is on display at Classic Cycle in Seattle, Washington. Courtesy of Classic Cycle

Sting-Ray style and the tandem seemed like an unnatural mating, but the company gave it a try with its Mini-Twinn. Courtesy of the Bicycle Museum of America

The Run-A-Bout was Schwinn's try at a portable folding bike. Courtesy of the Bicycle Museum of America

OTHER STING-RAYS

Schwinn tried a bicycle-built-for-two version of the Sting-Ray in 1968 with the Mini-Twinn, but mating a tandem with a cool Sting-Ray style seemed unnatural. It lasted just a year, meaning it was destined to become a top collector's item today.

Also in the Sting-Ray line, the Run-A-Bout, introduced in 1968, was built as a tiny adult commuting bike. When riders pushed the seat all the way down and lowered the handlebars to the frame, the bike became compact enough to toss in the trunk or store in the office. It came with a three-speed Sturmey-Archer shifter.

In 1971, Schwinn reached out to bigger kids with a version of the Sting-Ray called the Manta Ray. This cycle had larger wheels, more length, and a fatter seat, but older kids and young adults showed little interest; they were gravitating toward new ten-speeds and not models associated with kids. Manta Rays disappeared after two years.

In 1978, the company thought they were tapping into the teen mind-set by releasing the Sneaker, which had a banana seat designed like the footwear. Although the design seems whimsical and fun now, kids at the time wanted nothing to do with it, and the model tanked.

The big Manta Ray was geared for older kids but did not generate much enthusiasm. Courtesy of Classic Cycle

Schwinn tried many different versions of the Sting-Ray. The company thought it would tap into the sneaker fad, but its version—with a banana seat that looked like a laced-up sneaker—bombed. Courtesy of the Bicycle Museum of America

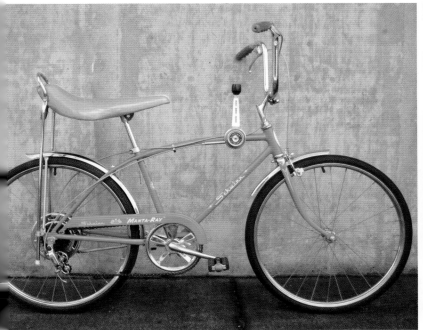

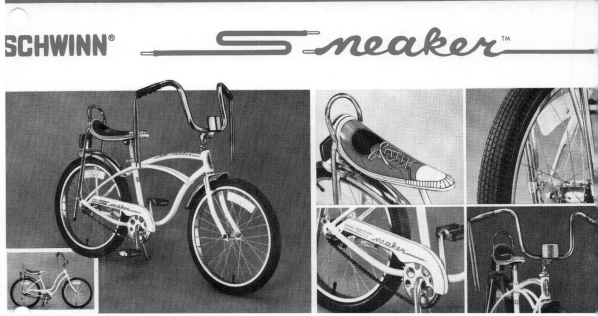

Chapter Eight

HITTING THE DIRT: THE LEAP TO BMX AND MOUNTAIN BIKES

THE FIRST HALF OF THE 1970S WAS a golden era for bicycle makers. Nationwide sales zoomed from 6.9 million in 1970 to 15.2 million in 1973, but then the streak started to fade, and by 1975, sales had plummeted by half, to 7.3 million units. Schwinn struggled to adapt, and in the early 1980s it closed its Chicago plants and relocated its domestic production to Greenville, Mississippi, in an effort to cut costs. This operation, however, was poorly managed and financial losses mounted. Schwinn also began importing bikes from Giant Manufacturing Co. of Taiwan, and National Bicycle Co. of Osaka, Japan.

Schwinn had always been on top of the game when it came to spotting new trends, but when the next one arrived they were a little late to the action. As with so many fads in the cycling world, the newest one once again developed in California. Just as with Sting-Rays, Krates, and touring bikes, cycling enthusiasts in the southern part of the state led the charge. They were modifying 20-inch frames so they could handle rough terrain, as found in motocross racing. Young cyclists looking for a new thrill took lightweight and rugged Schwinn Sting-Ray bicycle models and enhanced them with better springs and stronger tires. On these self-constructed machines, young riders would speed up and

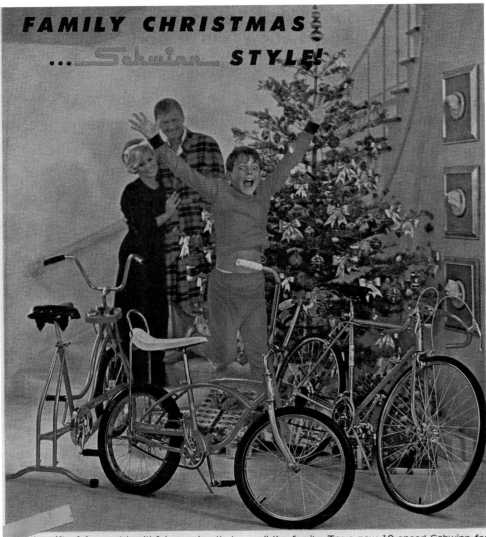

down hills, make sharp turns, perform tricks, and make jumps while racing through dirt and mud. They called the new form of biking "BMX," for "bicycle motocross."

When the motorcycle-racing documentary *On Any Sunday* came out in 1971, the BMX movement exploded. Children and teenagers were eager to imitate the bikers in the film. Like many skateboarders at the time, some BMX-ers performed daredevil stunts, including flying high off ramps, "getting air," and rotating their wheels 180 degrees. An era of extreme sports had arrived as these freestyle BMX riders practiced in empty swimming pools, concrete reservoir channels, skate parks, and city streets. The American Bicycle Association organized official competitions, and special BMX tracks were built across the country. According to Lou Dzierzak in his book *Schwinn*, about 130,000 BMX bikes were in use by the summer of 1974, and California alone had more than 100 BMX tracks. By 1976, BMX bikes comprised about 18 percent of all US bicycle sales.

It's a Schwinn Christmas in this ad from the 1970s: a ten-speed for Dad, a Schwinn Exerciser for Mom, and a Sting-Ray for Junior. Courtesy of the Bicycle Museum of America

Initially, Schwinn hesitated to get into the BMX market, concerned about the risks of injury. Other competitors, such as Mongoose bicycles, had sped to the forefront in the BMX arena. But as the trend swiftly grew and safety precautions became more routine, Schwinn joined in the action in January 1975 with the Scrambler (although it still had a banana seat and was still classified as a Sting-Ray). A year later, the company offered the Scrambler Competition BX5-6. For the Scrambler, designers beefed up a 20-inch Sting-Ray frame with heavy-gauge steel, reinforced welding, and a Sting-Ray handlebar braced with a crossbar for extra strength. The knobby tread design of the MX tires provided super traction in rain, mud, gravel, and other challenging conditions. The company advertised the Scrambler as "the new Sting-Ray that's robust, brawny, and bold!" Younger kids could get in on the action with a Mini Scrambler, featuring a smaller frame and 16-inch wheels.

By the summer of 1977, Schwinn was sponsoring a competitive BMX team. In 1978 and '79, a National Bicycle Association / Schwinn BMX tour hit the road, presenting BMX races and events in many cities across the country.

In the 1970s, the BMX craze took off, with young people eager to adapt motocross-style racing and stunts to the bike world. Courtesy of the Bicycle Museum of America

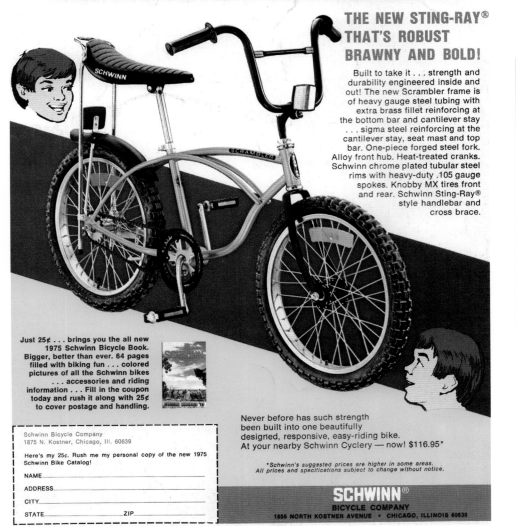

SCHWINN
SCRAMBLER™

THE NEW STING-RAY®
THAT'S ROBUST
BRAWNY AND BOLD!

Built to take it . . . strength and durability engineered inside and out! The new Scrambler frame is of heavy gauge steel tubing with extra brass fillet reinforcing at the bottom bar and cantilever stay . . . sigma steel reinforcing at the cantilever stay, seat mast and top bar. One-piece forged steel fork. Alloy front hub. Heat-treated cranks. Schwinn chrome plated tubular steel rims with heavy-duty .105 gauge spokes. Knobby MX tires front and rear. Schwinn Sting-Ray® style handlebar and cross brace.

Just 25¢ . . . brings you the all new 1975 Schwinn Bicycle Book. Bigger, better than ever. 64 pages filled with biking fun . . . colored pictures of all the Schwinn bikes . . . accessories and riding information . . . Fill in the coupon today and rush it along with 25¢ to cover postage and handling.

Never before has such strength been built into one beautifully designed, responsive, easy-riding bike. At your nearby Schwinn Cyclery — now! $116.95*

Schwinn's suggested prices are higher in some areas. All prices and specifications subject to change without notice.

Schwinn Bicycle Company
1875 N. Kostner, Chicago, Ill. 60639

Here's my 25¢. Rush me my personal copy of the new 1975 Schwinn Bike Catalog!

NAME _____
ADDRESS _____
CITY _____
STATE _____ ZIP _____

SCHWINN®
BICYCLE COMPANY
1856 NORTH KOSTNER AVENUE • CHICAGO, ILLINOIS 60639

Schwinn jumped into the BMX world with the Scrambler. The 1975 Catalog Supplement of Scrambler Parts and Accessories echoed the Peter Max style of the generation. Courtesy of the Bicycle Museum of America

1975 CATALOG SUPPLEMENT

SCHWINN®
SCRAMBLER™
PARTS AND ACCESSORIES

In 1977, the company brought forth the Scrambler 36/36 with it sturdy thirty-six-hole spoke tires, and an updated model featuring mag wheels. Die-cast from a magnesium alloy, mag wheels were originally used in drag racing. "Mag wheels" became synonymous with any type of die-cast wheels, whether they were made from aluminum alloy, plastic, or other material.

For a couple BMX models, Schwinn dug back into its past for names and a bit of style. The 1978 Hornet had a mounted mock MX

motorcycle gas tank—somewhat reminiscent of the gas tanks on the Black Phantom and other old heavyweights. Riders especially appreciated the overstuffed saddle when traversing rugged terrain. The Tornado offered a cheaper variation on the Hornet style: A flat piece of molded plastic filled in for the tank, and the seat had less padding.

Keeping with the cataclysmic weather theme, the Hurricane 5 whirled in. With its long, fat seat held up by simulated shock absorbers, it gave maximum comfort but was more of a pseudo BMX than a real competitive bike. The shifter attached to the head stem.

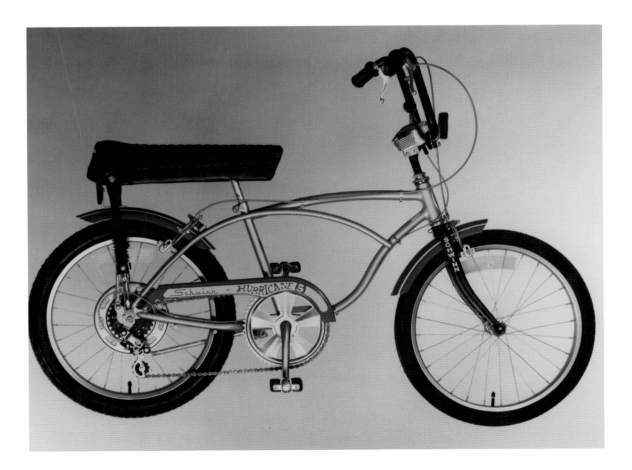

The end of the decade brought an affordable BMX, the Phantom Scrambler (retailing at about $120 to $145), and the more-serious Sting (selling for $500 to $600), hand-built by the high-end bicycle division called the Paramount Design Group (PDG). Although the Sting was a contender in the BMX world, to a large degree, Schwinn was behind the curve and couldn't quite catch up with its competitors.

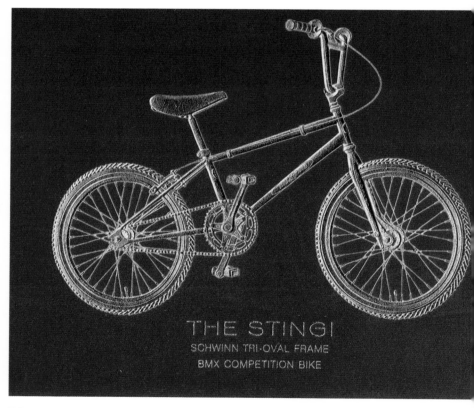

THE STING!
SCHWINN TRI-OVAL FRAME
BMX COMPETITION BIKE

The Schwinn Sting was featured on Schwinn's 1979 Christmas card, and by 1980, even Santa was getting into the BMX act. Note the mag wheels on the Phantom Scrambler. Courtesy of the Bicycle Museum of America

In the early 1980s, the Predator and Thrasher entered their lineup, and by the mid-1980s, new models included the Black Shadow, Streetwise, Qualifier, Aerostar, and Gremlin. A third edition of the Thrasher was distinguished by its light mag wheels with their few plastic spokes. Although production was outsourced to the Taiwan company Giant, serious BMX riders viewed the Predator as a very competitive entry at a competitive price. The Predator featured chromed standing platforms and dual-position pegs for performing tricks. Unfortunately, the Predator arrived in 1983 just as public interest in BMX was starting to fade. Still, at that point in the 1980s, freestyle BMX was big, where riders would perform a sequence of stunts and tricks often on curbs, handrails, stairs, ledges, banks, and other obstacles. By the 1990s, however, the high-flying times of BMX were over.

The Phantom Scrambler offered an affordable option for kids wanting to jump into BMX action. Courtesy of the Bicycle Museum of America

The Predator debuted in 1983. Courtesy of the Bicycle Museum of America

Rollfast

BICYCLE EXERCISER

WITH SPEED AND MILEAGE INDICATOR

Just as the BMX was fading from popularity, Schwinn would capitalize on a renewed interest in stationary exercise bikes. Al Fritz, who had bet on the Sting-Ray phenomenon, saw great potential in a new type of exercise bike. Different kinds of stationary bikes had existed for centuries; one called the Gymnasticon dated back to 1796. There was even a stationary bike in the gymnastics room aboard the *Titanic* in 1912. Today, stationary bikes are everywhere, and hugely popular at fitness centers where they give spin classes.

In 1965, Schwinn tapped into the growing fitness craze and released its first stationary bike for the home, called the Exerciser. While Schwinn continued to

dabble in stationary bikes over the years, it was Al Fritz's Airdyne Exerciser that gave the company a big lift. Fritz was constantly on the lookout for new ideas, and when two Australian product developers showed him the idea for an ergonomic stationary bike, he was sold. This home cycle, introduced in 1978, became a huge success through the 1980s, and helped the company to survive when it faced hard times financially. Using

Two early stationary bicycles, with a Schwinn model on the right. Courtesy of the Bicycle Museum of America

EXERCISER

AR-AROUND EXERCISE FOR THE WHOLE FAMILY

PEDAL THE CALORIES AWAY!

hour of bowling	225 calories
hour of golf	225 calories
hour of dancing	250 calories
hour of tennis	350 calories

You can use up to 400 calories in an hour of pedaling!

● PLANNING YOUR PERSONAL EXERCISE PROGRAM

featuring...

SCHWINN STATIONARY EXERCISE BICYCLES

Copyright © 1978
Schwinn Bicycle Company,
Chicago, Illinois 60639

a wheel with fanlike wind vanes, the wind resistance becomes exponential, so the harder you pedal, the higher the resistance becomes.

This system provided the right workout for both a novice exerciser and an elite athlete. Pulling and pushing arm levers provided upper-body exercise as well. As with the Sting-Ray, upper management at Schwinn resisted the idea at first, but Fritz persuaded them to try. With radio newsman Paul Harvey as the Airdyne spokesperson, the product pedaled its way toward becoming a runaway success (although it remained a stationary bike). In 1986, Schwinn's Excelsior division—which sold the Airdyne—was grossing $25 million a year. Although Ed Schwinn (the fourth-generation family president) should have embraced the popular stationary bike, he was reportedly angered by Fritz's success, perhaps seeing him as a threat to his leadership.

Schwinn Exercisers from 1968 (left) and 1978 (right). Courtesy of the Bicycle Museum of America

PEE-WEE HERMAN MAKES A SCHWINN A MOVIE STAR

In 1985, a Schwinn landed a starring role in a major motion picture. That year, Pee-wee Herman took to the big screen in his debut feature-length film, *Pee-wee's Big Adventure*. The story revolves around Pee-wee and his adoration for his fully accessorized, modified, red Schwinn bicycle. The bike is decked out with handlebar tassels, rearview mirrors, metal panniers (which are basically a pair of carrying bags slung over the back of the bicycle), and a big lion's-face decoration atop the head tube. Pee-wee's love for his bike knows no bounds: "I wouldn't sell my bike for all the money in the world. Not for a million, trillion, billion dollars!" He even had a dream where he raced ahead of the other competitors in the Tour de France on his crazy two-wheeler. Crushed after someone steals his beloved bicycle, a determined Pee-wee sets out on a journey to the Alamo, where he believes the red Schwinn is being kept in the basement.

Courtesy of Warner Bros.

For Paul Reubens, who plays Pee-wee Herman, the Schwinn was the inspiration for the entire film. In a speech at the Hammer Museum in Los Angeles, Reubens said he was struggling to write his movie on a lot at Warner Brothers, but he just wasn't feeling motivated: "In between writing, whenever I would take a break, I would walk around on the lot with the producers of the movie and complain about not having a bike. Everyone on the lot was riding a bicycle, and I kept going, 'What do you have to do to get a bike? How do I get a bike?' One day I came back from lunch . . . and out in front of my bungalow was

a 1947, fully restored, beautiful Schwinn racer. It actually is the bicycle on the poster. And it was chained to a post with a sign that had my picture on it, and it said, 'Parking for Pee-wee Herman Only.' And I looked at that bike, and I went, 'Oh my God, I'm writing the wrong movie.' Literally, I ran inside, pulled the paper out of the typewriter, and started typing, 'Pee-wee Herman loves his bike more than life itself.' It was all really just from walking in and looking at that bike."

Pee-wee's Schwinn is now part of movie history. According to the production designer on the film, Pedal Pusher Bike Shop in Newport Beach, California, constructed about thirteen of the souped-up Pee-wee red bicycles. The film crew damaged some doing stunts, and a few others were stolen—which is ironic, because the plot revolves around the bike being snatched. When the movie went on to become a blockbuster hit, grossing about $40 million, the bike soared in value. In 2014, an original bike from the movie fetched $36,600 on eBay.

One of the thirteen modified Schwinns used in the film *Pee-wee's Big Adventure* (1985) is on display at the Bicycle Museum of America in New Bremen, Ohio. Courtesy of the Bicycle Museum of America

Courtesy of Hermanworld

THE MOUNTAIN BIKE MOVEMENT

Overlapping with the BMX craze, another major movement in bicycling was developing—again in California. The phenomenon actually started out small in the late 1960s and early '70s, when a group of teenagers in Marin County, California, refurbished single-speed balloon-tire bikes of the 1930s and '40s, many of them old Schwinns. They wanted the fatter tires to roll more easily over rocks, ruts, and logs. They affectionately dubbed their new bikes "clunkers." Others nicknamed them junkers, bombers, ballooners, and cruisers. Whereas BMX bikes with their smaller frames and 20-inch wheels were made for agility, with handlebars that could spin for sharp turns and difficult tricks, clunkers used 26-inch wheels and bigger frames for longer treks. BMX bikes are typically single gear, while mountain bikes can have twenty to twenty-four gears. Some of the early tinkerers in the '70s rigged thumb-shifters from five-speed touring cycles to the clunkers. BMX bikes have no suspension, while mountain bikes can have front suspension or full suspension.

They wanted the fatter tires to roll more easily over rocks, ruts, and logs.

One of the movement's innovators, Gary Fisher, modernized a 1937 Schwinn Motorbike, fitting it with heavy-duty expander brakes and racing gears, so he could tear up and down hills at speeds of up to 30 mph. Joe Breeze, also considered one of the founding fathers of the mountain biking movement, designed many of the earliest versions, starting by modifying a 1941 Schwinn-built ballooner, a fat-tire paperboy bike.

By the 1980s, mountain bike designers had incorporated lightweight components and developed frames from chromoly steel (chromium-molybdenum steel), which is fairly light but has high tensile strength and malleability. Many offered motorcycle-like suspension, similar to the springer forks in the Black Panther and other old heavyweights.

Schwinn made its contributions in the mountain bike category, but again they faced fierce competition and fell behind competitively. In 1979, the company tried out

a pseudo mountain bike called the Spitfire 5, selling it as the Klunker 5 in some markets. In an attempt to transition into mountain bikes from BMX, Schwinn transformed a Sting, making an oversize version in the 1980s called the King-Sting, with both single-speed and geared versions. While the King-Sting cruiser boasted off-road capability, the 1982 Sidewinder was considered the company's first genuine mountain bike—basically a Varsity frame modified to carry fatter wheels. The following two years brought the well-engineered Mesa Runner, along with the Sierra

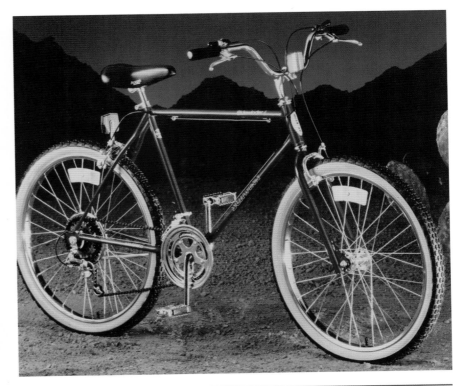

The Sidewinder and the High Sierra were Schwinn entries in the mountain bike market, but they could never quite gain on their competitors at the time—a case of too little, too late. Courtesy of the Bicycle Museum of America

and High Sierra, both built in Asia and marketed as "All-Terrain Bikes." The High Sierra gained respect among the mountain biking community, especially when Ned Overend became a top competitive mountain biker while riding it.

In an interview in *Outside* magazine, Overend said, "Back in 1985, when I was in high school, I saved enough summer pay to buy my first mountain bike. . . . My ride was a champagne gold steel Schwinn Sierra." In 1984, he got a job working at a Schwinn

dealership in Durango, Colorado. He bought a High Sierra, won the Pacific Suntour series races, and served as a spokesman for Schwinn. As Overend became a high-profile representative for the company, and other competitive racers took up Schwinn mountain bikes, the brand gained traction in the new revival of the balloon tire, which it had really originated fifty years before. In 1983, with fat-tire fervor mounting, Schwinn put out an old-style cruiser with a cantilever frame, cushy seat, and an old-style chain guard—but no fenders! Schwinn continued to produce mountain bikes into the early 1990s, like the twenty-one-speed Impact and the High Plains, which was touted as a mountain/urban sport bike.

LIGHTWEIGHTS PEDAL ON

By the 1980s, the Varsity was considered an American classic, and it continued on until 1986. One of the other original multispeeds, the Continental, bowed out in 1982. The Paramount experienced a renaissance in the 1980s when Schwinn engineer Marc Muller headed up the Paramount Design Group, which made custom bicycles tailored to each individual rider's precise measurements. From their shop in Waterford, Wisconsin, this new Paramount team built a reputation for constructing state-of-the-art racing bikes—starting modestly at fifty bikes a year, but producing about five hundred by 1983.

In 1981, Olympic medalist and road cyclist Eric Heiden became a spokesperson for Schwinn's "leanest, most sophisticated racing and touring machines we've offered." He's featured in a 1981 advertisement for lightweights "22 lbs and over; $2,500 and under." The company that started by producing lightweight racers in the 1890s was going back to its roots. Many of the racing bikes like the Paramount were too rich for average consumer tastes, so Schwinn offered a few similar but slightly less expensive machines, like the Peloton, Super Sport, and Tempo.

The company that started by producing lightweight racers in the 1890s was going back to its roots.

The ad with Heiden hawked the Paramount at $2,500, the Superior at $850, the Super Sport at $549, the Voyageur at $429, the Super Le Tour at $319, and a Le Tour at $254. Schwinn sponsored a top racing team in 1982 headed by Heiden that helped give new life to the Paramount.

In the late 1980s, the Schwinn racing team received cosponsorship from Wheaties, and was featured on the cereal box. Lance Armstrong, who is now banned for life from competitive cycling because of long-term doping offenses, also raced on a Paramount during that decade.

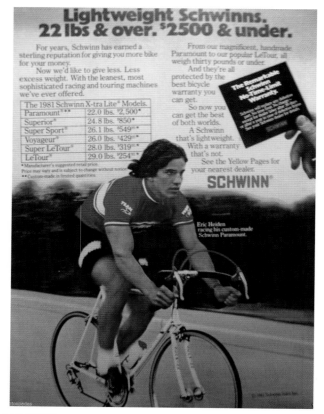

Olympic speed skater turned cyclist Eric Heiden was a Schwinn-sponsored athlete in the 1980s. Courtesy of the Bicycle Museum of America

The Schwinn racing team and "The Breakfast of Champions" were a natural fit in the 1980s. Wheaties featured the team on its cereal boxes. Courtesy of the Bicycle Museum of America

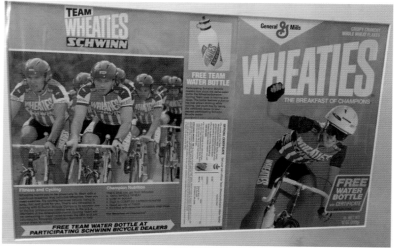

By the second half of the 1980s, Chinese manufacturers were producing a large portion of Schwinn bikes. Sales sank, costs rose, and quality suffered. The company bled money. In the early 1990s, Schwinn had bank loans totaling about $64 million. In 1992, just three years shy of its one hundredth anniversary, the original Schwinn company filed for bankruptcy, and Scott Sports Group bought the assets in 1993. Shortly thereafter, the company that had spent nearly one hundred years as a Chicago institution moved its headquarters to Boulder, Colorado. At the same time, Muller and Richard Schwinn, Ignaz's great-grandson, bought the Paramount factory and continued the Paramount line until 1994. Other builders made Paramounts up until 1998.

The Paramount Design Group kept alive the Schwinn legacy of building superior racers. Courtesy of the Bicycle Museum of America

SCHWINN: THE NEXT GENERATIONS

WHEN THE SCOTT SPORTS GROUP ACQUIRED SCHWINN IN 1993, they had their work cut out when it came to revitalizing the brand. The company advertised its proud heritage, but made it clear that Schwinn would be producing modern cycles. Two years after Scott Sports Group bought the company, the Schwinn brand was again making its mark under the Homegrown line of aluminum-frame mountain bike racing machines that ranged in price from $1,200 to $3,000. The firm not only rolled out a new line of cruisers, it also minted five thousand copies of a classic Black Phantom reproduction in 1995 to celebrate one hundred years of Schwinn. Although the reissued Phantoms carried a price tag of $3,000, they sold out almost instantly.

A century after the birth of the Schwinn bicycle, the classic Black Phantom was reissued in a limited run. Courtesy of Bicycle Museum of America

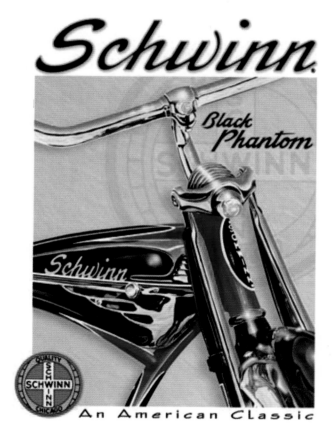

Schwinn

Black Phantom

An American Classic

In 1995, *Mountain Bike* magazine voted the Schwinn Moab S mountain bike "Best of Show." The bike was named after Moab, Utah, one of the meccas for mountain bike enthusiasts with its red rock terrain, range of trails, and spectacular views. (In its line of mountain bikes today, Schwinn continues to put out a Moab, with aluminum frame, suspension fork, mechanical disc brakes, and twenty-four-speed drivetrain.) In 1997, Homegrown issued other new cruiser models with classic cantilever frames. The new Schwinn owners tapped into nostalgia, reproducing the cruiser style with whitewall tires and big fenders. What was old was hip again.

As the mountain bike trend seemed to be peaking, however, Scott Sports Group found selling Schwinns to be an uphill battle. In *Crain's Business*, Charles T. Ferries, chairman of Schwinn parent Scott Sports Group, based in Boulder, Colorado, said, "It's taken us longer to turn the brand around than we anticipated. [The business] needs to go to another level. Maybe someone out there can do it better."

In the 1990s, the Moab mountain bike breathed new life into the Schwinn brand. The Moab 3, which Schwinn currently sells, features 29-inch wheels and a sturdy aluminum frame designed for cross-country riding over almost any type of terrain. Courtesy of Schwinn

Questor Partners took up the challenge. They acquired Schwinn and continued to tap into consumer nostalgia for old-model bicycles. Krates came speeding back on the market in 1998, almost identical cousins to the originals. With the Stik Shift banned in 1973, these were single-speed coaster-brake versions with springer forks and chrome fenders. In 1999, the Grape Krate made the scene, but with a limited run of 1,999, making it an eagerly sought-after machine in the current collector's market. That same year, when the Beatles' movie *Yellow Submarine* was rereleased, a Krate inspired by the animated feature was produced in a very limited run of about eighty—another rarity to find today.

In 2001, Schwinn once again changed hands. Pacific Cycle in Madison, Wisconsin, acquired the brand, and by 2002, it was selling the line through major retailers like

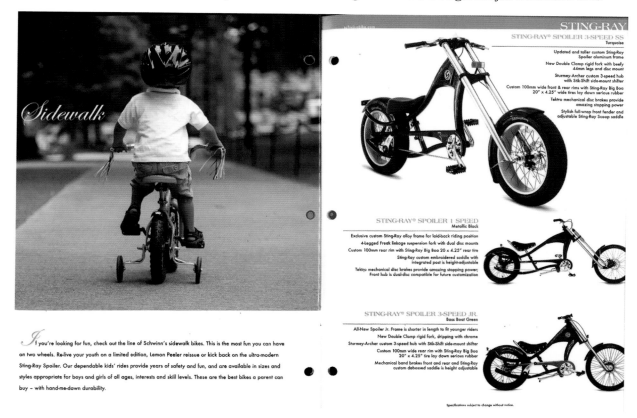

Walmart, Sears, Kmart, Target, and Toys "R" Us. The new Schwinn owner was dedicated to continuing the legacy of building quality Schwinn bicycles. In 2004, Dorel Industries purchased Pacific Cycle, giving Schwinn a wider global presence. That same year, the company brought back the Sting-Ray, with the same spirit of the original but a whole new chopper look reminiscent of the motorcycles in *Easy Rider*. The bike featured a low, motorcycle-style saddle adorned with chrome studs. The Big Boa back tire measured a super-fat 4 inches in width and 20 inches in diameter, while the front wheel was a slimmer 2 inches wide but 22 inches in diameter on some models. The 2007 catalog advertised the Sting-Ray Spoiler 3-Speed SS model, with its massive tubular long front end and fat front and rear tires, both at 4.25 inches wide.

For a while, Schwinn was offering electric bike models as well, including a Sting-Ray with an electric motor. In 2010, Schwinn reached out to the eco-conscious when it released the Vestige, with a frame constructed of 10 percent carbon fiber and 90 percent flax (from the plant that gives us linen). The frame featured a unique translucency so when the rider pedaled at night, LED lights inside made the bike glow in the dark. The fenders and grips were made from bamboo, and the tires were constructed of recycled materials.

In the mid-2000s, Schwinn gave pedalers a boost, introducing a line of power-assisted electric bikes. Courtesy of Schwinn

In 2013, Schwinn launched a limited edition of the Paramount, celebrating the seventy-fifth anniversary of the model, one of America's most popular ten-speed bicycles. Schwinn tapped Paramount engineering experts Marc Muller and Richard Schwinn, the great-grandson of Schwinn founder Ignaz Schwinn, to create the custom frames at Waterford Precision Cycles in Wisconsin.

Two years later, Schwinn joined forces with another iconic brand to create a limited-edition Levi's Kids x Schwinn bike, featuring a seat that looked stitched together like a pair of Levi's jeans and a rear reflector shaped like the Levi's batwing logo. In 2017, Schwinn revived the Lemon Peeler Krate with the classic springer fork, banana seat, ape-hanger handlebars, rear struts, and sissy bar. Reissued in a limited run

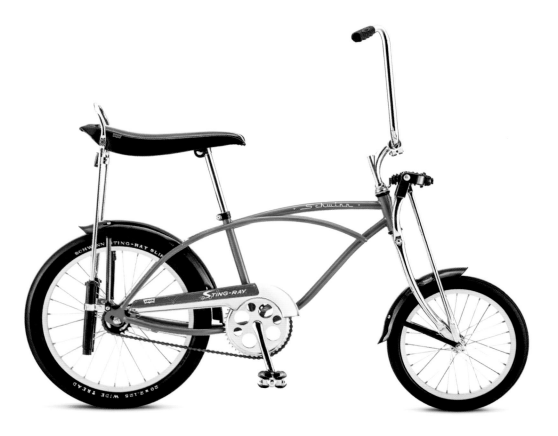

of five hundred and priced at $350, the new bike featured the 20-inch rear wheel and the 16-inch front wheel, but came with a single-speed drivetrain and coaster brakes.

While Pacific Cycle has been drawing on old styles, it has also been heavily targeting young millennial consumers, emphasizing the Schwinn as a fun, cheap, and green mode of transportation.

Living up to its legacy for innovation, Schwinn under Pacific Cycle added elastomer between the seat tube and the seat-stay junction and to the stem of its 2016 Vantage. They dubbed the innovation SRT—"Smooth Ride Technology." Elastomer is a lightweight synthetic polymer like rubber that helps to absorb vibration. In addition, the Vantage RX1 touts an eleven-speed drivetrain, smooth and easy shifting, Schwinn-copyrighted Ergo Endurance handlebars, carbon fork, and hydraulic road brakes.

The firm also developed the lightweight but incredibly strong N LITENED Black Label Carbon frame. In 2016, the company presented the Fastback Carbon Road

The Schwinn Streamliner combines vintage looks with such modern innovations as an elastomer saddle and grip shifters. Courtesy of Schwinn

The Schwinn Sivica. Courtesy of Schwinn

Line, a full-carbon road bicycle, with prices ranging from about $500 to $1,400. They also came up with a Relaxed Position Geometry design that provides the rider with a more-comfortable riding position than traditional comfort bikes. The slackened riding position creates the proper leg extension for ease of pedaling and efficiency while still allowing the rider to touch the ground when seated. This innovation has been a key selling point in the 2017 Schwinn recreational model called the Sivica, which comes in single- and seven-speed versions.

Currently, Schwinn sells classically styled cruisers with names that go back to the original balloon-tire models, such as Hornet, Panther, Debutante, Hollywood, Starlet,

and Corvette. The company offers a line of fixed-gear bikes, or "fixies," which have become trendy in the 2010s. The bike does not coast because it does not have a freewheel. If the rider stops pedaling, the bike stops moving. The appeal of fixies are their simplicity, and because they have fewer parts, they tend to be lighter. Schwinn also produces flip-flop hub fixies, which give the rider the option of engaging a freewheel and coasting.

The Schwinn Bike Path models are well suited for commuters and city riding. Most have aluminum frames and multiple speeds. Some of the popular bikes in this category have been the Voyageur series and the Schwinn 4 One One (named after the number to dial for information). Other new entries are mountain bikes, with their wide knobby tires, a stout frame, shock absorbers, and straight handlebars, and kids' bikes (some designed for mountain riding). Hybrid bikes are available for hitting rough terrain or tooling around town. The new Schwinn road bicycles have skinny tires, light frames, and a forward-leaning riding position that allows a cyclist to go fast on pavement. Schwinn's SmartStart line offers completely redesigned models of kids' bikes to better fit their bodies and riding needs, allowing easier and increased pedaling as well as better balance.

Currently, Schwinn sells classically styled cruisers with names that go back to the original balloon-tire models.

Pacific Cycle has breathed new life into the historic American brand, and while the company continues to update models with the latest technology, they also value the styles and sturdy construction that have made Schwinn an American classic. A new generation is finding that when it comes to bicycling nothing compares to a Schwinn—still the best present ever.

TODAY'S SCHWINN AMBASSADORS

A NEW CLASSIC FOR MODERN OUTINGS

As of 2017, twenty-three-year-old David Lowe was working as a Schwinn Brand Ambassador in Atlanta, Georgia, and finding that his Schwinn Classic Deluxe 7 provided the perfect means of transportation for local adventures. While this machine is a real throwback to the old heavyweights—including a 1955-style cantilever steel frame with integrated tank and horn, springer fork, fenders, rear rack, and integrated headlight—the Classic Deluxe also brings biking into the modern world with its seven-speed drivetrain. "It has many features that mimic a motorcycle, and would make James Dean yearn for it," said Lowe.

The Schwinn has turned Lowe into a regular local explorer. One of his favorite rides is through Piedmont Park in Atlanta, which Lowe calls the Central Park of the South.

The Schwinn has turned Lowe into a regular local explorer.

He says there is nothing better than enjoying the summer sun while riding past all the park-goers who are out playing volleyball, barbecuing, and riding their bikes. He often likes to pedal out to remote locations and find hidden gems like an open road leading to an abandoned farm, some urban/industrial ruins, or an old gas station. "I love to visit local treasures. Batman had the Batmobile and James Bond had an Aston Martin, but they both missed out because they never got to embark on journeys handling a Schwinn," he said.

A PERFECT CITY CYCLE

As a beauty guru who has written for dozens of magazines and appeared on major TV networks, Jeanette Zinno knows a thing or two about style. That's one of the reasons she likes buzzing around New York City on one of her modern Schwinns—blue Traveler, red Breeze (a heavier-style cruiser), or Coral Sivica. The modern Schwinn Traveler takes the American Classic look and updates it with modern colors, graphics, and urban functionality, and got its inspiration from the lightweight American cruisers of 1960s.

The vintage Schwinns give Zinno the comfort and durability she needs in the city streets—the perfect transport for urban living. She commutes from Brooklyn to Manhattan. "It's great because I get a little workout in while I commute," she said. "It's an easy and beautiful ride, and gives me time to think about my day or work through any problems in my mind." Zinno also finds her cruiser to be well suited for running errands at the farmers' market. She even puts her miniature pinscher, Rocki, in her bike basket when she zips over to a friend's house to pay a visit. "I see new things like architectural details, new stores, statues, etc., on my commute every day that I would probably miss if I weren't on my Schwinn," she said.

Zinno loves exploring other cities on the bike as well. She toured the Ninth Ward of New Orleans on a Schwinn a few years after Hurricane Katrina, and in Chicago, she explored the 606, a former rail line turned recreational trail, visited the Art Institute, and caught a Cubs game at Wrigley Field.

EMILEE'S GOLDEN RIDE

Emilee Morehouse of Seattle, WA, is a Schwinn ambassador who enjoys riding a gold Schwinn Mifflin Hybrid. This current model is a strong, lightweight seven-speed with a type of mixte frame. Pronounced MIX-tee in English, this type of frame is a variation on a standard step-through design for women and it is intended for "mixed-gender" use. Typically, mixtes have a pair of small-diameter tubes running from the head of the steering column to the rear axle. Some city riders prefer them for their easy dismount.

Morehouse described why she likes her Mifflin Hybrid: "It beautifully catches the sparkle of the

Jeanette Zinno and Rocki enjoy an outing in Brooklyn's Prospect Park astride her Schwinn red Breeze. Courtesy of Schwinn

sun, reminding me of summers spent at our county fair, where I always obsessed over the carousel. I've named my bike 'Valkyrie.' In Norse mythology this name refers to the women who chose, in battle, who was worthy of eternal glory in Valhalla. As someone who comes from a proud line of Norwegians and Danes, it seemed fitting. This bike marks the start of a new chapter. I've ridden a vintage Schwinn for the past five years, so I'm excited to see the adventures Valkyrie takes me on this year, and beyond. As an adult, biking offers so much more than being able to ride down the street. It's a lifestyle that requires you to get off the sidelines, and out on the next adventure. Biking has carried me from Seattle city parks to French war memorials. While the risk seems considerably less than when I was a little girl, it's the eternal question that keeps me peddling: 'Where to next?' "

Emilee Morehouse charges ahead into life on her golden Mifflin Hybrid, complete with a large basket mounted on the handlebars. Photo courtesy Victoriana Dan

From its earliest days Schwinn marketed to the Hispanic community with Spanish-language advertising, brochures, and maintenance manuals. This ad from the 1950s promotes *bicicletas de peso ligero*, or lightweight bicycles. Courtesy of the Bicycle Museum of America

A SOURCE OF PUERTO RICAN PRIDE

In Bushwick, Brooklyn, members of the Classic Riders and the Puerto Rican Schwinn Club glide through the city streets, showing off their love of old Schwinns—from the 1950s Black Phantom to the 1960s Jaguar to souped-up Krates. Some adorn their Sting-Rays with speedometers, horns, headlights, bells, streamers, and Puerto Rican and American flags. In an article in the *Wall Street Journal*, Eddie Gonzalez, a member of the Classic Riders, explained that they love to "dress up" their bikes. These Schwinn club riders express themselves through their rides and use them to connect with their pasts—Schwinns were sold in Puerto Rico for decades. Club members love fixing,

restoring, and showing off their machines. And it's not just the Nuyoricans (Puerto Ricans living in New York City) who worship Schwinns; clubs have formed in Chicago, Los Angeles, Cleveland, and other cities in the United States. In Illinois, the Chicago Cruisers parade around on their decked-out Schwinns, sometimes blasting salsa music as they go.

Luis Mercado, a mental health counselor who founded the Chicago Cruisers in 2000, talked about the club in an article in *Kickstand* magazine, noting, "We have three goals: Ride beautiful bikes, build friendships, and enjoy the sights of our wonderful city." The Cruisers say they are the biggest Puerto Rican Schwinn club, and they take special pride in the fact they are located in the birthplace of this one-of-a-kind brand.

In the same article, Chicago Cruiser Holt Ellis explained why these bikes are so popular in the Puerto Rican Community: "Latinos and African Americans, we all came up poor. Cruisers are accessible because you can buy one secondhand or piece it together and customize it to make it your own. They've become a Latino icon."

Miguel Luciano, a Puerto Rican artist based in Brooklyn, works in multiple media to examine issues of cultural identity, politics, and popular culture. In 2017, he exhibited a body of new work: sculptures featuring customized vintage Schwinn bicycles, to commemorate the traditions of Puerto Rican bike clubs in New York.

Visual artist Miguel Luciano uses Schwinn bicycles in his artwork. This piece is titled '51 (se acabaron las PROMESAS) [the promises are over], 2017. It features a 1951 Schwinn Hornet as a symbol of 1950s American modernity, paired with a black and white Puerto Rican flag as a contemporary symbol of protest regarding the economic crisis on the island. In working with Schwinn bicycles, Luciano uses the year of their production, their signature features, and bike color, as symbolic touchstones to represent aspects of Puerto Rican political history. Schwinn was one of the first American bicycles marketed in Puerto Rico. This Schwinn Hornet dates to 1951, the year before the island became a commonwealth. Courtesy of Miguel Luciano

JERRY AND FRASIER LIKE THE BIKE

In one episode of the sitcom *Frasier*, titled "Fraternal Schwinns," Frasier and his brother Niles agree to participate in a bike-a-thon for AIDS research, but neither brother knows how to ride a bike. When the physically awkward duo practice at night, disaster ensues as Niles's bike gets destroyed and Frasier keeps falling off.

In an episode of *Seinfeld* titled "The Seven," Elaine falls for a vintage girl's Sting-Ray she finds at an antique toy store:

ELAINE: (excited) That is a Schwinn Sting-Ray! And it's the girl's model! Oh, I always wanted one of these when I was little. What d'you think?

JERRY: Oh yeah, be great for your paper route.

ELAINE: (laughs) I love it. I'm getting it.

Later in the episode, Elaine and Kramer argue about ownership of the bike. When they go to Newman to resolve their dispute, the antagonistic mailman says they should split the bike in half. In the end, Kramer winds up selling the bike to Newman. At the end of the episode, Elaine chases him as he pedals down the street.

Credit: Bicycle Museum of America

As a Schwinn fan, Jerry Seinfeld paid $3,000 for one of the reproductions of the classic Black Phantom.

AN AMERICAN PICKER'S LOVE AFFAIR WITH SCHWINNS

Mike Wolfe, who cohosts the popular History Channel program *American Pickers* along with Frank Fritz, has had a lifelong love for bikes, including Schwinns. When he was a kid, he found a bunch of old banana-seat bikes from the 1960s in the garbage and brought them home to fix up. As he became an avid collector, he got into buying balloon-tire Phantoms and Panthers. He appreciated their horn tank, spring on the front end, and light on the front fender. Two of his most prized picks have been a 1938 cantilever Schwinn Autocycle and an Aerocycle from the 1930s.

A SCHWINN FOR LIFE

Schwinn built a reputation for reliability with its lifetime guarantee. Donald C. "Pat" Malone certainly put that promise to the test. After owning his New World Traveler model for more than sixty years, Malone has proven how dependable and sturdy a Schwinn can be. He's still riding the bicycle today. In 1953, Malone was working a paper route and diligently saved up the $75 needed to purchase this latest model from the local bike shop in Pueblo, Colorado. The bike was different from other models that Malone and his friends knew. They had been riding heavier frames with fat tires; this was a lightweight with a new three-speed gear shift internalized in the oversize Sturmey-Archer hub of the rear wheel.

"From that time on, the Schwinn became my primary mode of transportation," said Malone. "I rode it to school each day, and I rode it to various friends' houses."

The Schwinn provided Malone with transportation throughout his life. He rode it when he went to college and to and from various jobs. After he got married and became a minister in Cheyenne, Wyoming, he rode it to church. Occasionally, he took

his two children on the bike—his daughter took the seat, and his son sat on the rear fender while he pedaled, standing up.

The bike was stolen in 1975, but was later recovered.

Along the way, Malone has had to replace various parts, but the New World is still basically the same bike he bought as a teen. Now retired to Farmington, New Mexico, after residing a total of thirty years in Colorado, Malone continues to ride his Schwinn regularly for pleasure and exercise.

"Some of my colleagues are amused that an eighty-year-old man still rides the bicycle he rode in his youth," he said. "But I love my bicycle. It's a little worn, and not as attractive as it once was, but it's still the same bicycle. My bicycle and I have grown old together."

Photo by Scott M. X. Turner

FROM A STOLEN SCHWINN, A HEAVYWEIGHT CHAMP IS BORN

In September 2016, the city of Louisville, Kentucky, teamed up with the Schwinn Bicycle Company to honor the legacy of Muhammad Ali by giving away one hundred free bikes to deserving kids in his hometown. The young Ali said he had taken up boxing after a neighborhood bully stole his Schwinn.

BIBLIOGRAPHY

DK/Penguin Random House. *Bicycle: The Definitive History*. New York City: DK/Penguin Random House, 2016.

Dzierzak, Lou. *Schwinn*. St. Paul, Minnesota: MBI Publishing Company, 2002.

Love, William. *Classic Schwinn Bicycles*. St. Paul, Minnesota: MBI Publishing Company, 2003.

Mitchel, Doug. *Standard Catalog of Schwinn Bicycles 1895-2004*. Iola, Wisconsin: KP Books, 2004.

Pridmore, Jay and Jim Hurd. *Schwinn Bicycles*. Osceola, Wisconsin: Motorbooks International Publishers & Wholesalers, 1996.

Rea, Steven. *Hollywood Rides a Bike*. Santa Monica, California: Angel City Press, 2012.

THANK YOU TO:

Becky Macwhinney and all the staff at the Bicycle Museum of America, 7 W. Monroe St., New Bremen, Ohio 45869

Samantha Hersil at Pacific Cycle, Madison, Wisconsin.

Steven Rea, author of *Hollywood Rides a Bike*.

Paul Johnson at Classic Cycle, 740 Winslow Way NE, Bainbridge Island, WA 98110

Miguel Luciano, artist, Brooklyn, New York

Scott M.X. Turner, photographer, Seattle, Washington

Paul Reubens and Allison Berry at Hermanworld

Julie Polkes

THE HISTORY OF SCHWINN-A TIMELINE

• **1895**

October 22: Ignaz Schwinn and partner Adolph Arnold form the bicycle business Arnold, Schwinn & Company.

• **1896**

Schwinn starts its racing program with its World Team. They had more victories than any other bike company.

• **1899**

June 30 Riding in the slipsteam of a Long Island Railroad locomotive, Charles "Mile-a-Minute" Murphy is the first man to go 60 mph by bicycle.

• **1902**

Bicycling is an adult-driven market. A racing bike costs $150 ($3,550 in today's dollars).

• **1908**

Frank. Ignaz Schwinn buys the interest of his partner, Adolph Arnold, and becomes the sole owner of Arnold, Schwinn & Company.

• **1909**

With the advent of affordable automobiles, bikes become passé for adults and the market largely shifts to children's bikes.

• **1911**

Schwinn buys Excelsior Motor Manufacturing & Supply Company, investing in internal combustion engines and surviving through the bicycle slowdown of the era.

• **1917**

Schwinn buys Henderson Motorcycle Company.

• **1920s**

The Motorbike bicycle and Auto-Bike lead the way into the new era of heavyweights. While they had no motors, these cycles draw influence from the motorcycles and autos of the early 1900's..

• **1930**

Schwinn becomes the standard of innovation for the industry.

• **1933**

Arnold, Schwinn & Company introduces the bicycle balloon 26-inch x 2.125-inch tire.

• **1934**

The Schwinn Aerocycle took bicycle design to the next level, with its sleek airplane-style look.

• **1935**

Schwinn introduces the Cycelock "the final solution" to the bicycle theft problem.

• **1936**

Schwinn presents the "Auto Cycle" Deluxe balloon tire bicycle, featuring the Schwinn full floating saddle and seat post, plus twin headlights and speedometer.

• 1938

Schwinn introduces the fore-wheel brake, cantilever frame, and the springer fork. This style is considered the grandfather of today's off-road bicycles.

• 1939

The Cycle Truck, a delivery bicycle built in '39 but popularized in the 1940s continues into the mid-1960's.

• 1940s

Although the Paramount Racer line starts at the end of the 1930s, these bicycles received much attention in the 1940s when French professional cyclist Alfred Letourneur rode his Paramount the fastest mile.

• 1941

May 17 Alfred Letourner sets a speed record of 108.92 mph pedaling a Paramount bicycle.

• 1943

Schwinn receives the Army and Navy "E" award for Excellence. Schwinn produces military items in World War II, including top-secret electrical devices, shells, ammunition, plane parts, and numerous other war-related items.

• 1946

Built-in kickstands are one of the new features that help improve post-war sales.

• 1949

The Schwinn Black Phantom is introduced as the top of the balloon tire line and wows young bike riders. The machine features many attractive features—chrome fenders, horn, tank, whitewall tires, head and tail lights, springer fork, deluxe saddle, and more.

• 1950s

Black Phantom and other heavyweight bicycles lead the way to a bicycling boom during this decade.

• 1952

The Schwinn Authorized Dealer Network begins and the company expands the genuine parts and accessories program.

• 1960

Schwinn introduces the Varsity 8-speed and Continental 10-speed bicycles. The Varsity teaches America to ride a touring bicycle.

• 1963

With high-rise handlebars, banana seat, and sissy bar, the Sting-Ray becomes a hit among kids. By 1964 The Sting-Ray sells over 45,000 units.

• 1965

Seeing the trend towards fitness, Schwinn introduces the first in-home workout machines.

• 1967

January 1 Arnold, Schwinn & Company officially becomes the "Schwinn Bicycle Company."

• 1968

Inspired by muscle-car styles, Sting-Ray Krates were another huge hit with American youth.

- **1970s**

Although the Varsity starts in 1960s, it becomes one of the most popular bikes of the 1970s and beyond.

- **1970s**

Aimed at the adult market, the Schwinn Suburban comes equipped with a basket, fat seat, derailleur gears, and upright handlebars.

- **1970s**

Schwinn releases the Le Tour a lug-framed, lightweight sleek racing bike.

- **1975**

Schwinn jumps into the BMX market with the Scrambler.

- **1978**

Schwinn releases the Airdyne Exerciser to great success.

- **1980**

The Paramount operation moves to Waterford, Wisconsin, where each Paramount bike was made custom to the exact specification of its individual rider. The Waterford outfit continues to produce Paramounts until 1994.

- **1983**

The BMX Predator proves to be popular among BMX riders but arrives as the BMX trend is slowing down.

- **1995**

The Homegrown Series brings high-tech, lightweight mountain bike production back to Schwinn. The new Schwinn line includes the new Moab S voted best of show by *Mountain Bike* magazine.

• 1996

Schwinn introduces the Straight 6® downhill specific bike, featuring dossiers full of secret technology.

• 1998

Schwinn re-introduces its Sting-Ray and Krate bicycles, wildly popular models offered in the late sixties and early seventies.

• 2004

The Sting-Ray reappears with a new look. The 20" juvenile bike is an immediate success and sells nearly 600,000 units in less than a year, reportedly making it the fastest-selling bicycle in history.

• 2006

Schwinn develops Nlitened Black Label Carbon and produces a line of fast, lightweight bicycles.

• 2010

Schwinn moves to Madison, Wisconsin. Dorel Industries Inc. purchases Schwinn's parent company, Pacific Cycle, bringing further stability and global presence to the Schwinn brand.

• 2013

The Schwinn Vestige is a commuter bike with an eco-twist. Its organic, recyclable Flax fiber provides a similar performance benefits as a carbon fiber frame, but its construction process produces a much lower carbon footprint.

• 2013

To mark the 50th anniversary of the iconic Sting-Ray created by Schwinn engineering vice president Al Fritz, Schwinn produces a limited run of 500 completely chrome-plated Sting-Rays. The bike is dubbed the "Fritz Fifty."

• 2014

Schwinn develops Relaxed Position Geometry for the rider who craves comfort; applying the design to several classic cruisers and bike path models for the new generation.

• 2016

Schwinn reaches out to their community to find 25 Brand Ambassadors to take up the torch and represent the brand. Diverse in age, gender, race and, biking capabilities, the Schwinn Ambassadors represent every Schwinn rider.

Using SRT technology, Schwinn adds elastomer to the saddle of the Vantage, making a bicycle that can tough out multiple terrains without the bothersome vibrations and bumps.

With kids in mind, Schwinn researches how to make kids bikes fit their young riders better. The result is the SmartStart bicycle.

Schwinn creates the Fastback Carbon a full carbon road bicycle. Schwinn reintroduces Nlitened Carbon with the full carbon Fastback model at a low price point; allowing more riders to experience a carbon bicycle.

• 2017

After the resounding success of Relaxed Position geometry, Schwinn offers increased comfort with the new Sivica line.

ABOUT THE AUTHOR

DON RAUF has written more than 30 nonfiction books, including *Killer Lipstick and Other Spy Gadgets, Simple Rules for Card Games, Psychology of Serial Killers: Historical Serial Killers, The French and Indian War, The Rise and Fall of the Ottoman Empire,* and the book series *Freaky Phenomena.* He has contributed to the books *Weird Canada* and *American Inventions.* He is a regular writer for Mental Floss and Health-Day. An avid bike rider, Don lives in Seattle with his wife, Monique, and son, Leo.